IMAGES
of America

MOSQUITO FLEET OF SOUTH PUGET SOUND

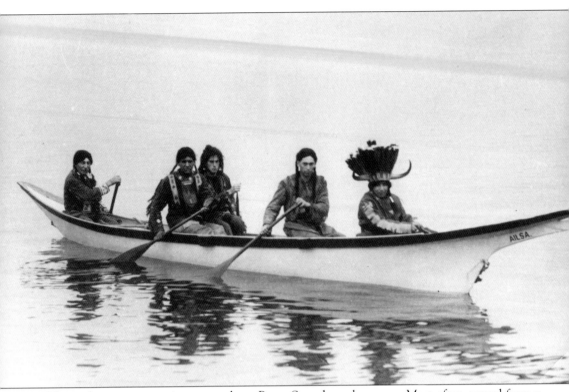

The earliest transportation on southern Puget Sound was by canoe. Most often carved from a single cedar log, it was stable, speedy, and seaworthy. It could travel easily on a river or the open sound, allowing the local native population to follow fish runs or pull up on the beach to dig clams and geoducks. For the first settlers, ignorant of tides, currents, and storms, paid transport by canoe assured safe arrival at the traveler's destination. (Points Northeast Historical Society.)

ON THE COVER: Named in honor of Shelton pioneer and timber magnate Sol G. Simpson, who died a year before she was launched in 1907, the stern-wheeler *S. G. Simpson* was built for Shelton Transportation Company; designed by her first captain, Edward Gustafson; and constructed by Tacoma's Crawford and Reid at a cost of $35,000. The handsome boat was 117 feet long, 23 feet in beam, and could carry 150 passengers. (MCHS.)

IMAGES
of America

MOSQUITO FLEET OF
SOUTH PUGET SOUND

Jean Cammon Findlay and Robin Paterson

ARCADIA
PUBLISHING

Published by Arcadia Publishing
Charleston SC, Chicago IL, Portsmouth NH, San Francisco CA

Printed in the United States of America

Library of Congress Catalog Card Number: 2007935825

For all general information contact Arcadia Publishing at:
Telephone 843-853-2070
Fax 843-853-0044
E-mail sales@arcadiapublishing.com
For customer service and orders:
Toll-Free 1-888-313-2665

Visit us on the Internet at www.arcadiapublishing.com

To the pioneers' descendants who cherished the memories and recorded the stories; without them there would be no book.

CONTENTS

ACKNOWLEDGMENTS

Unless otherwise credited, the photographs came from Robin Paterson's own collection.

Julie Albright, our editor at Arcadia Publishing, supplied expertise, guidance, and advice. Merci beaucoup.

We thank the many wonderfully helpful people staffing institutions that provided information and pictures. Where credited, we use abbreviations for these organizations: Anderson Island Historical Society (AIHS); Fox Island Historical Society (FIHS); Gig Harbor Peninsula Historical Society (GHPHS); Key Peninsula Historical Society (KPHS); King County Archives (KCA); Mason County Historical Society (MCHS); Museum of Puget Sound (MOPS); Points Northeast Historical Society (Pts NE); Puget Sound Maritime Historical Society (PSMHS); University of Washington Libraries, Special Collections (UW); Vashon-Maury Island Heritage Association (VMIHA); and Washington State Historical Society (WSHS).

Research help also came from Des Moines Historical Society, Museum of History and Industry, Port of Allyn, Tacoma Public Library Northwest Room, Seattle Public Library, and Steam Ship *Virginia V* Foundation.

The exquisite maps in chapters one, two, three, and four were created especially for this book by the inimitable Ronald Burke. Thanks pale in comparison to his contribution.

We tip our hats to the kind people who offered help, proofread, taught computer skills, shared stories, and gave advice: Elton Cleveland, Reed Fitzpatrick, Gary Frankel, Claudia Johnston, Lao Kiriazis, Richard Parker, Mark Shorey, Colleen Slater, Phil Spencer, Laurie Tucker, and Teresa Williams and to the many individuals whose personal photographs are credited herein. We especially bow to Photo Pro of Gig Harbor, to Harold Carter for his technological proficiency, and to Robin's dear friend Harley Somers for his generosity. We particularly thank Elizabeth Gallentine for her honesty and skill in proofreading our text.

And thanks to our spouses extraordinaire, Kae Paterson and Gilbert Findlay, for their unflagging patience, support, encouragement, even pride, and most certainly love: our grateful obeisance. We couldn't have done it without you.

INTRODUCTION

"Mosquito Fleet" refers to the myriad of steamboats that served the Puget Sound's needs for the more than 50 years that straddled the dawn of the 20th century. The name, so the story goes, came from a fellow in an office overlooking Elliott Bay and remarking as he observed all the boat activity that it looked like a "swarm of mosquitoes." Apocryphal or not, the name stuck.

Just what qualified a boat to be a member of the Mosquito Fleet?

Not size. The smallest was less than 40 feet long and the largest was nearly 300 feet. As passenger and freight businesses grew, the boats became larger, and there came a distinction in nomenclature. Generally boats over 50 feet were called steamboats; those under that were called launches.

Not routes. When they first arrived (the *Beaver* was earliest to the Northwest in 1836), these boats ran all over Puget Sound and even into Canada. They simply went where they were needed. By 1880, they began to settle into regular routes, though boats changed hands and moved to different parts of Puget Sound (often referred to simply as the Sound) quite often.

Not propulsion. There were stern-wheelers, side-wheelers, and propellers.

Not fuel. In the beginning, they were steam powered, first by wood, later by coal, and still later by oil. There were experiments: non-steam engines boiled naphtha (an idea soon abandoned) and then, more safely, were fueled with gasoline. Boilers sometimes exploded, or heat caused fires with disastrous results. And the engines required a lot of fuel. There is no estimate of the amount of timber that went up the smokestacks before the boilers were converted to other energies.

Not cargo. They delivered, to name a few examples, passengers, mail, newspapers, produce, fish, eggs, bricks, shingles, brush, and logs. Basically if there was water access and it could be loaded or towed, a Mosquito Fleet boat took care of it.

Not jobs. So many boats did so many different duties that it was not always possible to define a boat as towboat, freight boat, or passenger boat.

In the beginning, the early steamers were built elsewhere—England, the East Coast, San Francisco, or Portland—and their designs reflected riverboats, which had shallow drafts for traveling at low water, an advantage on Puget Sound. Before docks, a boat that could run up close to a sloping shore needed only a gangplank to load passengers and goods. If that was not possible, the transfers took place from a rowboat.

By 1880, local builders began competing in the growing market for boats. Not all boats were built in boatyards though. Some were built on the beach, like the *Virginia V*, even as late as 1922.

In design, an early steamboat usually had a wooden hull with a sharp bow, a fine stern, a wide flat deck, and a flat bottom. The lower deck contained the engine and space for cordwood (later fuel tanks), cargo, and passengers. These designs evolved as the engines gained more power and freight, such as crates and cars, became bulkier. If there were an upper deck, passengers would be carried there, often in separate cabins; the men could smoke in theirs. Facilities ranged from primitive to elegant, occasionally with a dining room. Staterooms were sometimes offered on very long routes, perhaps from Olympia to Victoria, but were not part of the standard design.

In short, a Mosquito Fleet boat was a craft of any size that performed any required task on Puget Sound. The fleet was the lifeblood of the community and commerce that launched the Pacific Northwest.

This book celebrates those boats that plied southern Puget Sound. While there are several books about Mosquito Fleet steamboats, not much has been written specifically for this area. This book celebrates the multitude of boats that stayed close to home, seldom venturing north of Seattle. Not every boat that sailed here is included. Some boats began work before cameras were common. Other boats were simply camera-shy. Many of the available pictures were taken to commemorate special occasions, usually Sunday excursions, rather than the ordinary work-a-day world of the other six days of the week. Several pictures show boats with fir trees tied to their masts, denoting Christmas festivity.

Our story is told chronologically from chapter to chapter and within each chapter. Olympia was the first distribution center for mail brought overland from Portland, and Olympia for a brief moment had the first customhouse, requiring all boats arriving in Puget Sound to stop there first. The customhouse moved to Port Townsend, and mail was also distributed from Steilacoom, but Olympia remained a hub. The boats in the first chapter all ran from Olympia.

The story is also told by region. The second, third, and fourth chapters recount steamboat history around Case Inlet, Carr Inlet, and Vashon-Maury Island, respectively. When the major routes were established, travel by the big and famous steamboats carried the burden from Olympia to Seattle and provided the connections to points beyond. This is the fifth chapter. Chapter six recognizes that with the invention of cars, the steamboats supplemented rather than dominated transportation. By the late 1910s, automobiles were here to stay and had to be moved. So by 1920 came the car ferry. Size determined the fate of the steamers. Several of the big steel-hulled steamers could be converted to car ferries, while the smaller boats were destined to finish life as tugs, freighters, or excursion boats (without fixed schedules). Many others were demolished or wasted away.

Looking back, it was a nostalgic era. Steamer schedules governed daily lives, and the whistle of the approaching boat was the call to collect the mail, greet friends, or send a package. To ride on a steamboat was an occasion, a chance to visit and enjoy the leisurely, often long passage to the city. Old-timers recall the smooth, gleaming wood in the passenger cabins, the box lunches en route, and the fact that, for a child, the journey enlarged the world.

We strived for accuracy; any errors are ours alone.

One

IN THE BEGINNING

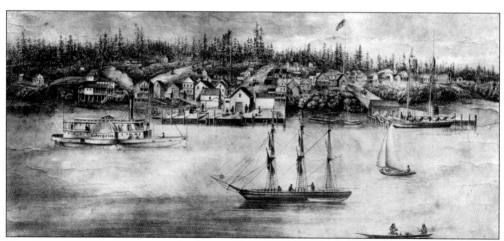

Founded in 1854, Steilacoom was the first incorporated town in Washington Territory. Early settler Lafayette Balch built a store and wharf in 1851 to establish a lumber trade with San Francisco, and Steilacoom's first post office opened in 1852, which made it a hub for mail distribution by steamer throughout the south Sound. By 1858, Steilacoom was the busiest city on the Sound, as this 1862 painting illustrates. Approaching on the left is the Hudson's Bay Company's 143-foot wooden side-wheeler *Enterprise*, built in 1861 in San Francisco. She was sold in 1883 to Canadian Pacific Navigation Company. The *Enterprise* collided with the *R. P. Rithet* off Ten Mile Point on the Victoria–New Westminster route in 1885 and was so badly damaged that the hull was stripped and abandoned.

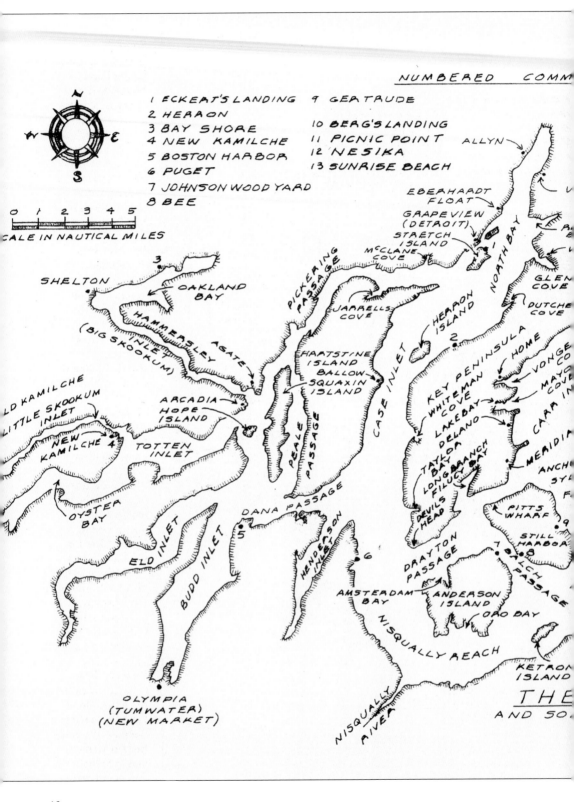

1 ECKEAT'S LANDING
2 HERRON
3 BAY SHORE
4 NEW KAMILCHE
5 BOSTON HARBOR
6 PUGET
7 JOHNSON WOOD YARD
8 BEE
9 GERTRUDE
10 BERG'S LANDING
11 PICNIC POINT
12 NESIKA
13 SUNRISE BEACH

SCALE IN NAUTICAL MILES

0 1 2 3 4 5

THE
AND SO.

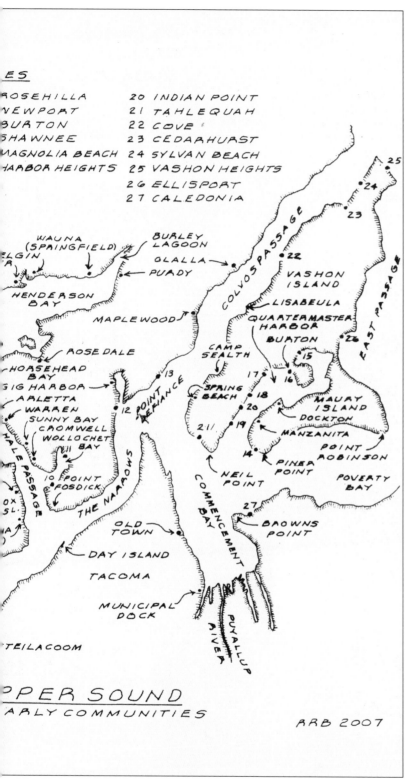

WAUNA (SPRINGFIELD)
ELGIN
BURLEY LAGOON
OLALLA
PURDY
HENDERSON BAY
MAPLEWOOD
ROSEDALE
HORSEHEAD BAY
GIG HARBOR
ARLETTA
WARREN
SUNNY BAY
CROMWELL
WOLLOCHET BAY
POINT FOSDICK
THE NARROWS
DALE PASSAGE
OX SL.
OLD TOWN
DAY ISLAND
TACOMA
MUNICIPAL DOCK
STEILACOOM

COLVOS PASSAGE
VASHON ISLAND
LISABEULA
QUARTERMASTER HARBOR
BURTON
CAMP SEALTH
SPRING BEACH
POINT DEFIANCE
MAURY ISLAND
DOCKTON
MANZANITA
PINER POINT
POINT ROBINSON
NEIL POINT
EAST PASSAGE
POVERTY BAY
COMMENCEMENT BAY
BROWNS POINT
PUYALLUP RIVER

13
12
17
16
15
18
20
21
19
14
27
10

PPER SOUND
EARLY COMMUNITIES

BRB 2007

South Puget Sound, also called Upper Puget Sound, is the area that starts at an imaginary line just north of Tacoma in a bight in the shoreline referred to as Poverty Bay and then extends south to Olympia and west to Shelton. It includes the many inlets, bays, islands, and peninsulas that create the extensive shoreline where settlers, beginning in the 1850s, found their livelihood as lumbermen, farmers, and fishermen. As the population grew, ancillary businesses developed: stores, brickyards, boat builders, dry docks, hotels, and services for summer visitors. Since there were only trails in this land, heavily forested to the water's edge, the population was supported by the steamboats collectively called the Mosquito Fleet that used the Sound as a watery freeway to move mail, products, and passengers.

11

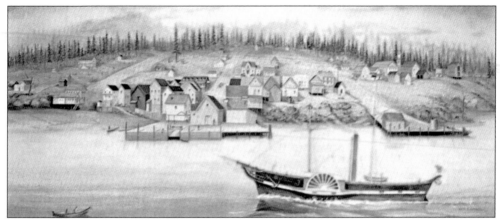

The Hudson's Bay Company's 100-foot SS *Beaver*, shown at Steilacoom in this 1858 painting by Kenn E. Johnson, was the first steam-powered vessel on Puget Sound. Built in England, she arrived in the Northwest in 1836 and spent the next 52 years bringing supplies and hauling goods until she wrecked on rocks at the entrance to Vancouver's harbor in 1888. (AIHS.)

No photographs of the *Fairy* exist, so Bob Ulsh, grandson of Lakebay pioneers and a Mosquito Fleet hobbyist, painted this picture from his research. The first American steamboat and the second to appear on Puget Sound, the *Fairy* was a San Francisco–built side-wheeler, arriving in November 1853 on the deck of the bark *Sarah Warren*. She had the first scheduled commercial service from Olympia to Seattle. (Ronald and Constance Burke.)

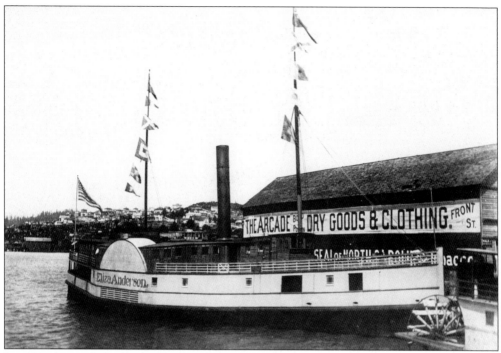

In 1859, the newly built side-wheeler *Eliza Anderson* arrived from Portland to institute the first reliable scheduled service from Olympia to Victoria. During 12 years on this route, she made huge profits and held off all competitors. Safe, steady, and comfortable, at 140 feet and powered by a walking-beam engine, she had a 30-year career on Puget Sound. She sank in Alaska in 1897.

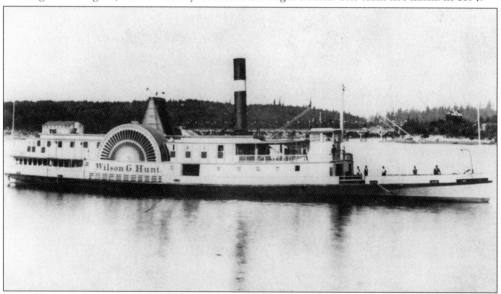

The 185-foot side-wheeler *Wilson G. Hunt*, built in New York in 1849, went to San Francisco in 1850. By 1859, she plied Puget Sound, replacing the steamer *Constitution*. She spent the 1860s on the Columbia River, returning to the Sound in 1869 to compete with the *Eliza Anderson*, but "old *Anderson*" prevailed. Returning to San Francisco, she was broken up in 1890 and sold for her iron. (MOPS.)

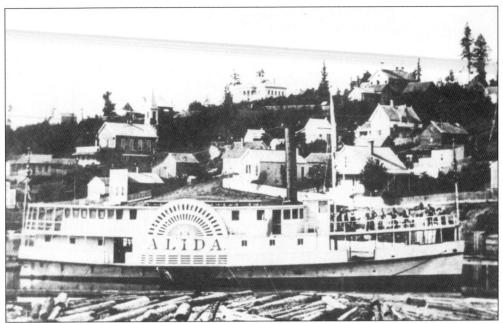

The 115-foot *Alida*, shown preparing for an excursion in Seattle on July 4, 1870, was built in 1869 with 12 staterooms for the Olympia-Victoria mail route, though when she proved too fragile for the Strait of Juan de Fuca, she ran instead Olympia–Port Townsend two times a week. While laid up in Gig Harbor in 1890, she burned in a brush fire that swept down from the forest.

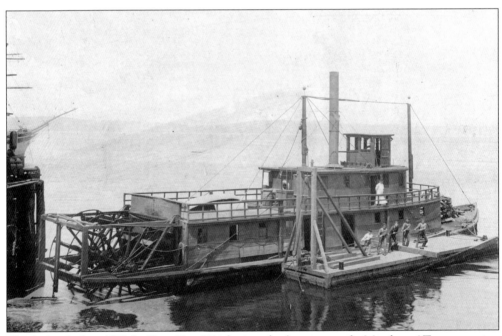

The *Zephyr*, built in 1871 for Capt. Tom Wright, was the first steamer for Merchants' Transportation Company, founded 1872. She ran on alternate days to her competitor, the *Messenger*, a boat of similar design, on the Olympia-Steilacoom-Tacoma-Seattle run, also stopping wherever else a flag was raised. After a venerable career, she was sold in 1907 for scrap to a Seattle junk dealer.

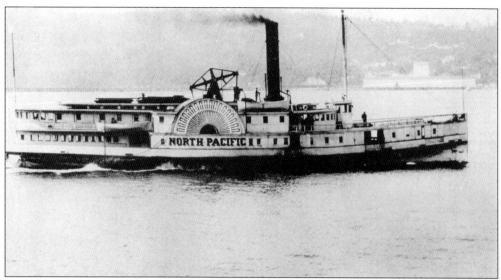

The *North Pacific*, equipped for sail as well as steam with a walking-beam engine, boasted 28 staterooms, a saloon deck, and a ladies' cabin. Built in 1871 in San Francisco, the 178-footer beat the *Olympia* in a race from Victoria to Port Townsend. In 1903, she struck rocks off Marrowstone Point and sank in deep water after everyone was rescued.

The 87-foot, Portland-built *Otter* first towed barges for Renton Coal Company in 1875 and then ran in competition with *Zephyr* and *Messenger*. Though badly damaged in a collision with the *Hassalo* off Des Moines in 1890, she was rebuilt and in 1892 became a Tacoma-based floating store, making weekly rounds on the upper Sound. She was moored and abandoned in the Puyallup River in 1897. (PSMHS 1847.)

The Tumwater-built, 91-foot stern-wheeler *Messenger* was launched in 1876. As population grew, so did her stops and special charters, such as delivering first settlers Andrew Miller to Fox Island, the Eckerts to Grapeview, and the Lorenzes to Longbranch. She had separate cabins for men and women and a double whistle that sounded like an organ chord. She burned at her mooring in Tacoma in 1894. (KPHS.)

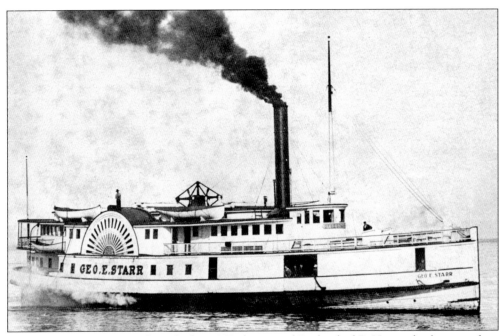

After the *Geo. E. Starr* was launched in 1879, she carried Rutherford B. Hayes, the first president to visit Seattle. Her captain, Gunder Hansen, was nicknamed "Jingle Bell Johnny" because he rang a bell for a heavy cart to be dragged to the high side as ballast when the *Starr* listed as she made a turn. She was the last side-wheeler operating on the Sound when she retired in 1911.

Two

OLYMPIA TO ALLYN

The first settlers established logging and sawmilling as the major industry on the arms of Case Inlet, this southwestern reach of Puget Sound. Settlements were usually at the mouths of creeks, which could provide waterpower for the mills, creating, for example, Allyn, Shelton, Arcadia, and Olympia. There were no roads—it would take a long time to build roads—instead, water provided easy transport for settlers. Rowboats came first, though the heavy tides, ripping currents, and often-inclement weather made this form of travel slow and onerous. Mills also needed a way to ship timber, so they hired or built their own steamboats, and thus a unique transportation business was born.

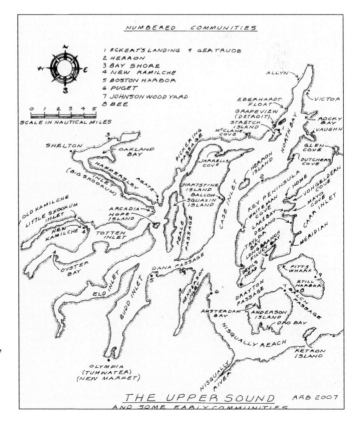

NUMBERED COMMUNITIES

1 ECKEAT'S LANDING
2 HERRON
3 BAY SHORE
4 NEW KAMILCHE
5 BOSTON HARBOR
6 PUGET
7 JOHNSON WOOD YARD
8 BEE
9 GERTRUDE

SCALE IN NAUTICAL MILES

THE UPPER SOUND
AND SOME EARLY COMMUNITIES
ARB 2007

There is little information about many Case Inlet boats, for some not even a picture, save that they are included in lists of boats remembered as calling at various stops. Many were one-owner/captain-boat operations; they saw a need for a service and went where the money was. They did yeoman duty picking up produce, fish, clams, oysters, bricks, and passengers and delivering supplies—even filling shopping lists for isolated settlers—as well as transporting excursions or tow boating. Such were *Estella*, *E. M. Gill*, *Maggie Yarnow*, and *Orion*. Others yield more information, but the picture is elusive, like *Capitol*, *Clara*, *Old Settler*, *Arrow*, and *Seaside*. Two others, *White Cap* (above) and *Colby* (below), built at Seattle in 1884, are at least commemorated in these two rare photographs. (Above MCHS.)

Samuel Willey (with his wife, Lydia) and his family came from Maine. Sons Lafayette and George got a mail contract for Olympia to Oakland about 1870 and soon purchased the little steamer *Hornet*, founding S. Willey Navigation Company, which they named to honor their father, who soon joined the business. Among boats they owned were *Susie*, *Willie*, *Multnomah*, and *City of Aberdeen*. (MCHS.)

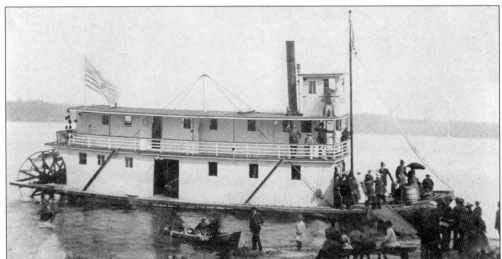

A husky workhorse at 67 feet long and 15 feet wide, the stern-wheeler *Willie* was built in Seattle in 1883 by Capt. W. H. Ellis for use on the Samish and Nooksack Rivers near Bellingham. She was soon bought by S. Willey Navigation Company to replace the smaller *Susie* on its Shelton-Olympia route. (MCHS.)

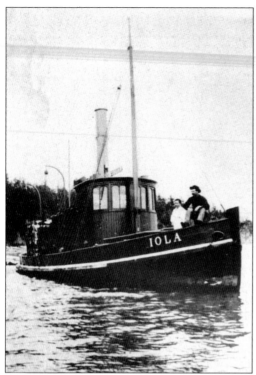

The *Iola*, shown with Capt. Thomas Redding seated on the bow, was built for Capt. Edwin Miller and launched at Big Skookum in June 1885. She ran weekly from Oakland to Olympia to Seattle, but within six months, this expanded to twice a week. In June 1887, John F. Vanderhoef became master and agent for Miller. By 1889, Vanderhoef had dropped the upper Sound route to serve Vashon Island exclusively.

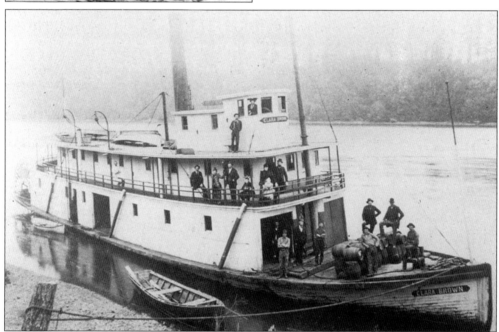

The 100-foot *Clara Brown* was built by Hiram Doncaster for Brown's Wharf and Navigation Company in 1886 and named for Capt. Thomas Brown's young daughter. She served for years on the Henderson Bay route that included Olympia, Kamilche, Shelton, Steilacoom, Tacoma, and Seattle and is famous for being the first boat to bring Seattle relief supplies after the great fire in June 1889. (VMIHA.)

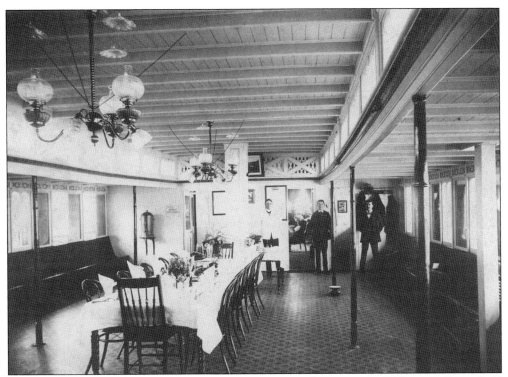

Built in Portland in 1885, the 143-foot *Multnomah* originally ran on the Willamette River. Sold in 1889 to the Willeys, she served on the Olympia-Seattle route. Her dining room, between the men's and ladies' cabins, usually seated four to six people at tables laid with white linen and flower bouquets grown in the family garden at Johnson's Landing, where she stopped for cordwood. On a foggy morning in November 1904, in Commencement Bay, she collided with the French sailing ship *Admiral Cecille*, passing under the bowsprit where an anchor's fluke ripped the *Multnomah*'s starboard upper deck. She ended in a similar accident October 1911, again in a dense fog, in Elliott Bay when she was rammed by the steamer *Iroquois* and sank in 240 feet of water. (Both MOPS.)

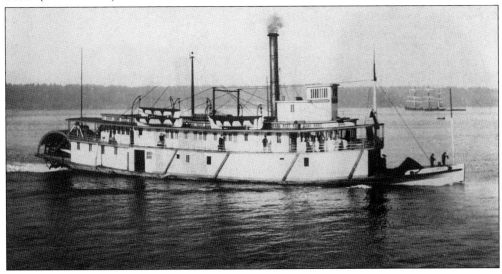

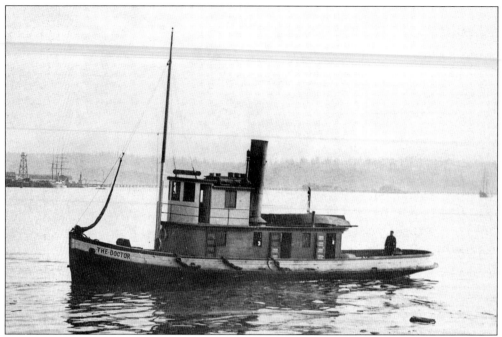

A small steamboat of only 57 feet, *The Doctor* was built in Olympia in 1890 and made daily trips from Olympia to New Kamilche and Shelton. In 1898, she was converted to a tugboat for Blekum Tug and then later bought by Puget Sound Bridge and Dredging Company, which changed her name to *Miami* and used her as a bridge tender. In 1906, she sank near Bristol Bay.

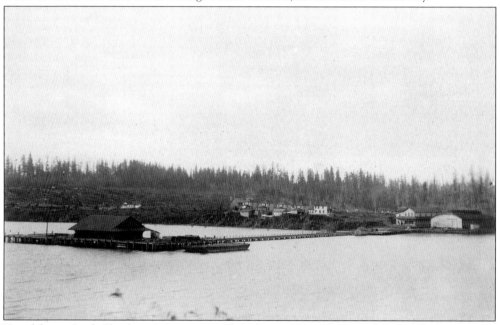

Kamilche, on Little Skookum Inlet, was established as a port for the steamboat link between Puget Sound and Grays Harbor Railroad, which was built in the 1880s to carry logs to the Port Blakely Mill, and as traffic between Grays Harbor and Seattle. In 1889, the line was extended three miles south to New Kamilche (shown above), and a dock was built in Oyster Bay for steamboats. (MCHS.)

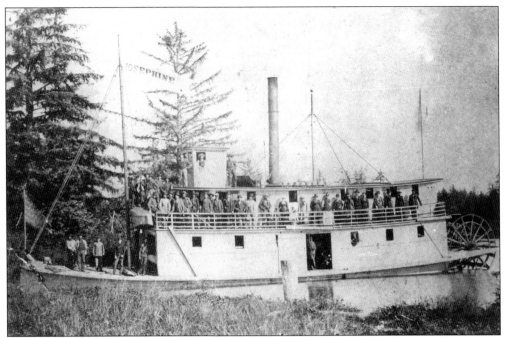

The *Josephine*, built in 1878 in Seattle, had a 14-year career. In January 1883, off Port Susan, her boiler blew, killing eight crew and passengers. The hull was relatively undamaged; she was rebuilt, and then ran on the Snohomish route until 1891, when M. L. Lewis bought her to run between Olympia and Shelton. In February 1892, while tied up in Allyn, she burned to the waterline. (WSHS.)

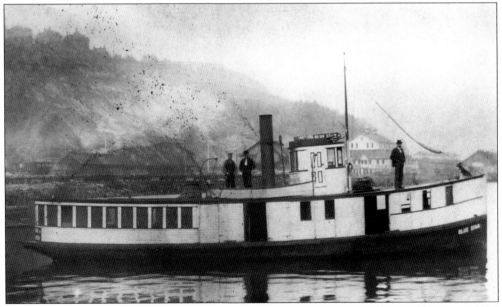

At 32 tons and 55 feet in length, the *Blue Star* was built as a passenger boat in Tacoma in 1892 by brothers Iver and Peter Foss. She burned in 1893 but was quickly rebuilt. Capt. O. G. Olson of Olson Tug Boat Company later converted her to a tug, and she ended life in 1907 in a fire at Mud Bay near Olympia. (PSMHS 4254.)

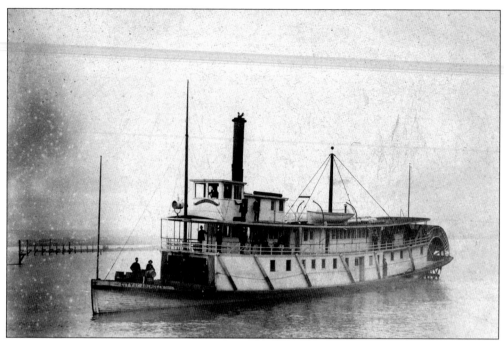

The *City of Aberdeen* (above), built in 1891 in Aberdeen, Washington, for the Aberdeen Transportation Company, went to the Shelton Transportation Company in 1892 for the Olympia-Seattle route. Around 1900, under a colorful captain with a competitive spirit and racing fever, John T. Shroll, known as "Hell-Roarin' Jack," the stern-wheeler waited one day for the speedy *Flyer*'s approach to Tacoma. Then just as the *Flyer* slowed to make the turn into Commencement Bay, the *Aberdeen* poured on the fuel, or in this instance, its hefty cargo of cased bacon, and before the *Flyer* even knew it was racing, the *Aberdeen* had passed the *Flyer*'s dock and Hell-Roarin' Jack was claiming victory. About 1907, *Aberdeen* became a tugboat and then was rebuilt as the *Vashon* (bottom), serving the Whidbey Island resort trade. She burned in 1911.

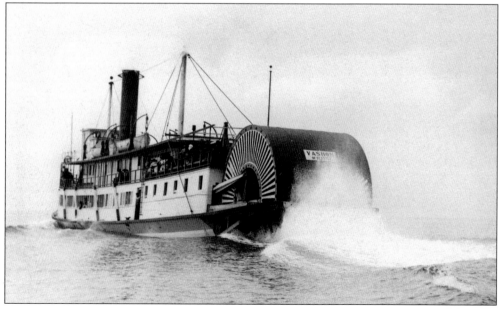

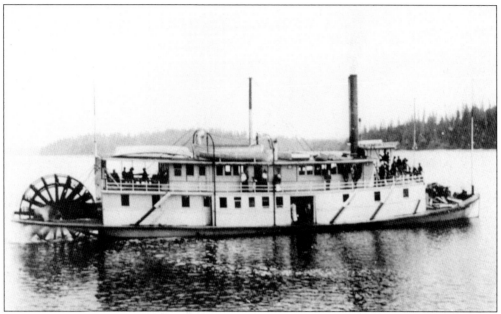

The 100-foot stern-wheeler *City of Shelton* (above and below, right, with *S. G. Simpson* at Shelton in 1910) was built in Shelton in 1895 for Shelton Transportation Company for the Olympia-Shelton run. She replaced *Willie,* and in 1907 she was replaced by the *S. G. Simpson.* Though steamboat captains were noted for their ability to navigate tough passages by ear, the *City of Shelton* once ran aground on Arcadia Point in a fog at low tide. The enterprising cook lowered a bosun's chair, dug three geoducks, and served chowder to the passengers while waiting for the tide to come in. In 1912, American Tug Boat Company bought her but did not use her. She was left in Dead Water Slough on the Snohomish River where she finally disintegrated about 1930. (Above Susan Parish.)

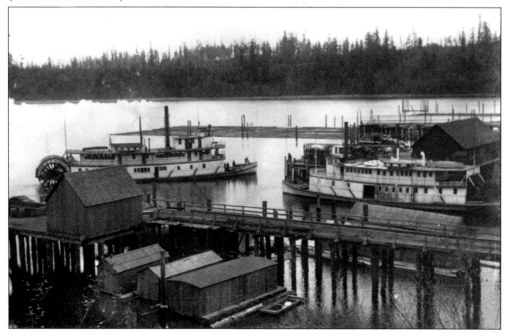

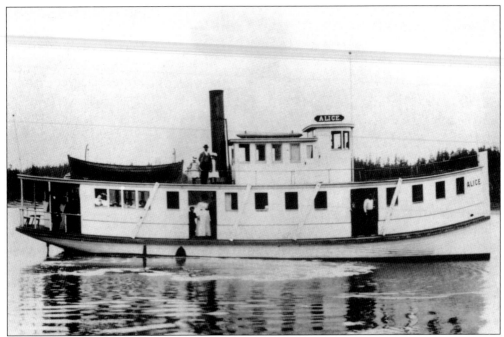

The 65-foot *Alice*, built in Old Tacoma in 1897 for Capt. James Bradford, ran in Case and Carr Inlets. Sold to Petersburg Packing Company in 1920, she spent 20 years in Alaska before returning to Puget Sound as a steam tug for Delta V. Smyth of Olympia. Rebuilt in 1930 and given a diesel engine, she then served the Foss Company 1941–1963 as the *Simon Foss*. (PSMHS 151–2.)

Built in 1893 as the *Emma Florence*, in 1898, she was rechristened *Marguerite*, lengthened to 58 feet for a new owner, and put on the Olympia–Harstine Island run until 1903. About 1909, again with new owners, the *Marguerite* (seen here in Commencement Bay) ran between Tacoma and Quartermaster Harbor and then went to an Everett-Mukilteo-Langley route. From 1913 to 1915, she worked on Lake Whatcom until she was destroyed by fire.

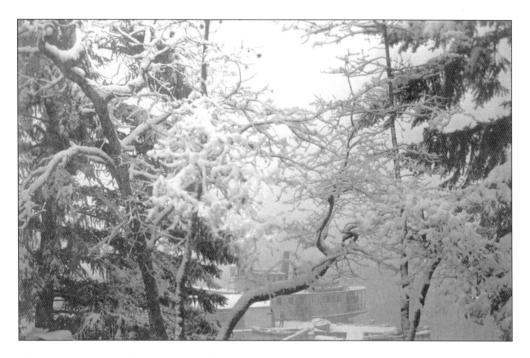

The entrance to Vaughn Bay is so shallow that steamers anchored outside the sandspit, a sandbar that is never submerged, and goods were transferred by rowboat until a floating dock was built around 1885. In the above photograph, taken by Vaughn storekeeper Harry Staley Coblentz, a winter snow around 1900 coats the trees above the *Alice*. In the photograph below, logs wait in the bay to be sawn into lumber by the Austin mill on the left. Vaughn and Vaughn Bay are named for William Vaughn, who homesteaded there in 1851, though he later lost his claim and moved to Steilacoom. Vaughn became an important steamboat terminal for the north end of Key Peninsula, and the scheduled stops became events known as Boat Days. (Both KPHS.)

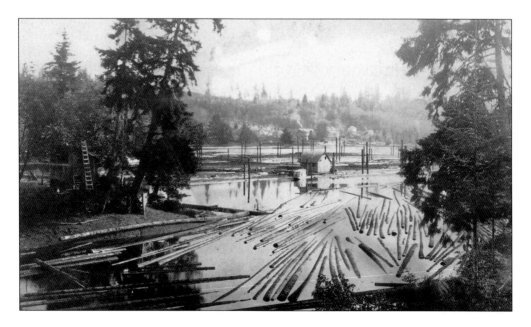

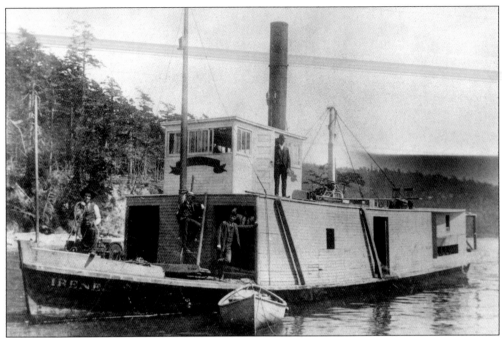

This 1899 photograph shows the long and narrow stern-wheeler *Irene*, built in Seattle in 1899 at 84 feet by 16 feet and powered by two one-cylinder 9-by-25-stroke engines. She worked the upper Skagit River and then, in 1904, went to Shelton Transportation for the Shelton-Olympia run until she was sold in 1921 to American Tugboat. She was converted to diesel in 1929. (MOPS.)

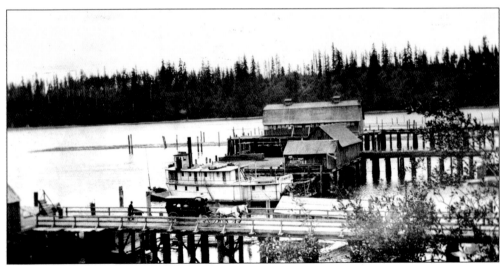

Shelton lies in the crook of a narrow arm once known as Big Skookum, now on maps as Hammersley Inlet. Settlement began about 1853 when the first industries were logging and sawmills. The town was named for pioneer homesteader David Shelton, a first member of the territorial legislature. In this 1908 picture, *Irene* is moored as a depot wagon leaves for the Webb Hotel.

Kim Munson built *Agnes* in 1900 to use around Shelton. She served between Carr Inlet and Tacoma 1911–1912 when her skipper was Capt. Della Walck, one of the few women on Puget Sound to get her pilot's license. In this picture, *Agnes* unloads passengers by pulling a rowboat back and forth. Because of her propeller, she couldn't pull up next to the beach to use a ramp. (MCHS.)

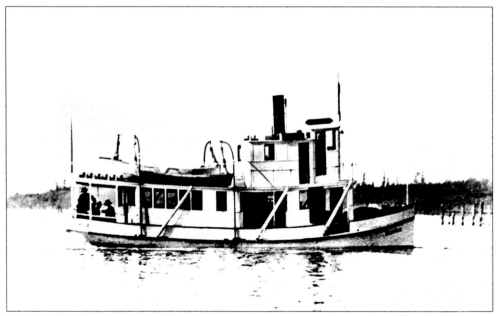

The 55-foot *Mizpah* handled both freight and passengers on a mail route from Olympia to Hunters Point, Rolling Bay, Oyster Bay, and Kamilche. Though the keel was laid in 1901 in Olympia, construction was not completed until 1905. She served until 1915 before she burned to the waterline and was rebuilt as a steam tug for Capitol City Tug Company of Olympia. (Susan Parish.)

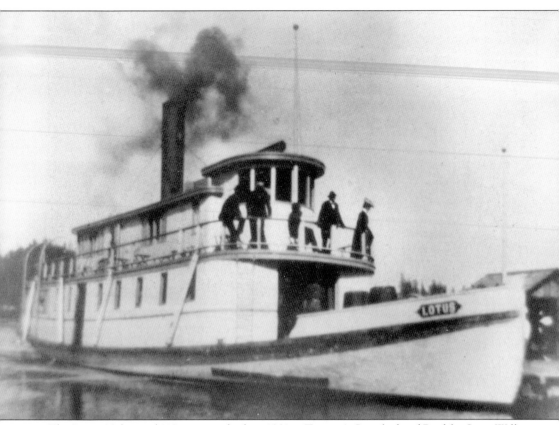

The *Lotus*, 92 feet and 112 tons, was built in 1901 at Tacoma's Crawford and Reid for Capt. William Bradford. She replaced *Alice* on the Tacoma–North Bay route. In July 1903, she was sold to the army quartermaster department, renamed *Cartwright*, and assigned duty as an artillery tender, but principally she transported military personnel to and from the forts in the area designated as the Harbor Defenses of [north] Puget Sound. In 1912, she was reassigned to San Francisco for similar duties, where she operated until 1921. In July of that year, she was sold to two Bay Area men, who named her *Lotus* again and intended to put her on a San Diego–Ensenada route, but in September, en route to San Diego, she caught fire in her cargo hold and burned to the waterline off Anacapa of the Channel Islands, where she now lies at the bottom of the sea. (GHPHS.)

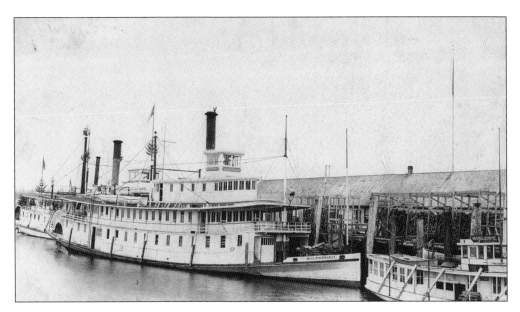

Platted in 1850 and named for its view of the Olympic Mountains, Olympia lies at the southern end of Puget Sound in Budd Inlet. Unsurprisingly the first exports were timber and oysters. In the 1850s, Olympia was site of the first port of entry, the first customhouse, and the first seat of government for Washington Territory. Edward Giddings built the first wharf in 1855. In 1860, Samuel Percival and son John built Percival's Dock, which served a multitude of boats, like those shown above in this 1900 Christmastime photograph (note the trees attached to the masts). They are, from left to right, the *State of Washington*, *Multnomah*, and *Marguerite*. In the 1910 picture below, from left to right, the smaller propeller boats *Prince*, *Blue Star*, and *Sophia* lie in front of the stern-wheelers *City of Shelton*, *Capital City*, and *Irene*.

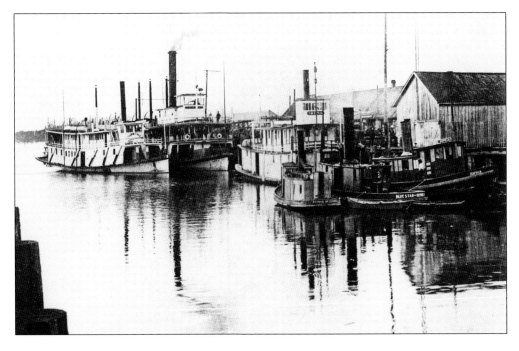

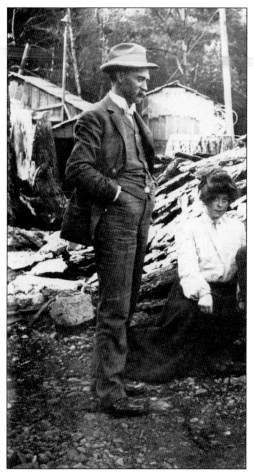

Sol G. Simpson (left, with an unidentified woman) came to Washington in 1877 and by 1900 owned the largest logging company and was the largest employer in the state. Steam donkey engines and steam locomotives were among technologies he introduced to logging. In 1900, he succumbed to gold fever and went to Nome, Alaska, where, among his enterprises, he operated three steamboats. But his venture soured, and he lost everything except a portion of Simpson Logging Company and an item Mary "Tollie" Simpson called the "$50,000 corkscrew" because it was all that was left from Nome. When Simpson died in May 1906, his family chartered the *Multnomah* to take them and his casket to Seattle for burial. Below, the *S. G. Simpson* awaits launching at Crawford and Reid in Tacoma. (Above MCHS; below MOPS.)

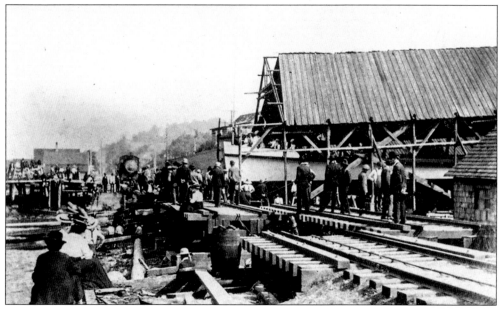

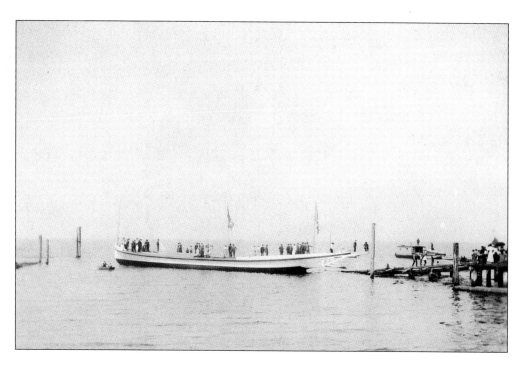

Named in honor of the pioneer timber magnate, the stern-wheeler *S. G. Simpson* was built in 1907 for Shelton Transportation Company; designed by her first captain, Ed Gustafson; and constructed by Crawford and Reid. The above photograph shows only the 117-foot hull was launched; the superstructure, below, was added afterward. She ran daily on the Shelton-Olympia-Tacoma route for 20 years, the Shelton-Olympia leg taking only 90 minutes. By 1922, she was carrying freight from Shelton to Tacoma, and in 1926, ownership was transferred to Puget Sound Freight Lines. In 1928, the passenger cabin was removed, she was renamed *E. G. English*, and she became a Skagit River tug. The once proud "*Sol G.*" was abandoned in 1945 and destroyed by the Army Corps of Engineers. (Above MCHS.)

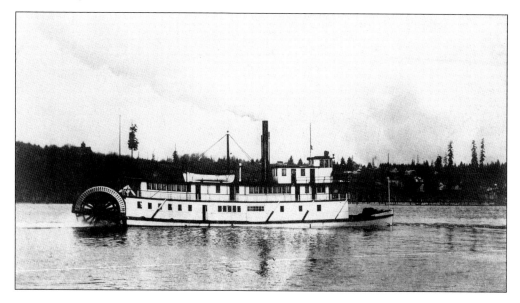

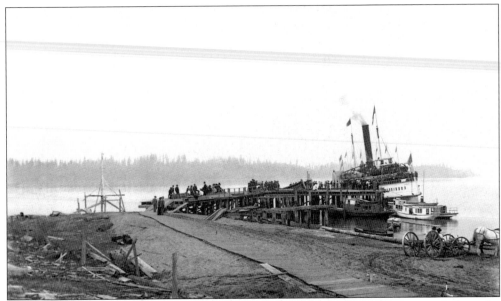

One of the longest steamboats at 282 feet, the 1863 side-wheeler *Yosemite* came north from the Sacramento River to Vancouver, British Columbia, in 1883 before moving to Puget Sound as an excursion boat. Such was this 1907 occasion when real estate manipulator Clarence Dayton Hillman offered a free trip with dinner, music, and dancing to view his Boston Harbor site. In 1909, she wrecked on Port Orchard Rocks. (Susan Parish.)

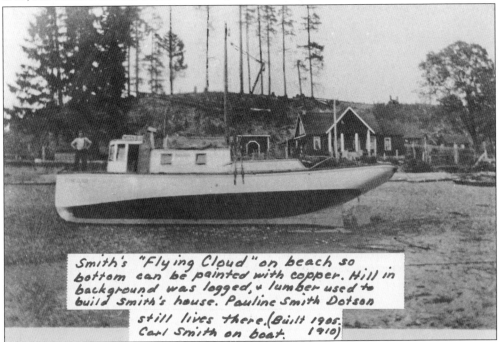

The 40-foot seiner *Flying Cloud* awaits a new coat of copper paint while lying on the beach at Victor. Owner Carl Smith raised oysters. Behind, the hill was logged between 1905 and 1910, and the lumber was used to build Smith's house. In the 1960s, *Flying Cloud* was at Ketchikan still working as a purse seiner. (MCHS.)

Among the Harstine Island boats doing jack-of-all-trades work were two launches belonging to Adam Ervin Cowan, a Missouri-born farmer with a large acreage on the west side. His boats, shown at Cowan's Landing, were *Lavina* (left), named after his wife, and *Leota*. In 1908, he had a 45-footer built at Dockton to replace his first boat, *Lavina*, and named her after his newborn daughter and seventh child, Leota. Cowan's boats carried freight and passengers to Olympia and also towed logs. One evening in December 1918, Cowan was working alone on *Leota* at low tide when her supports failed and the boat rolled, crushing him to death. The final disposition of *Lavina* is not known, but after Cowan's death, *Leota* was sold to and operated on the upper Sound by Robert Wallin of Olympia. In 1950, she was bought by a logger, a Mr. Satterthwaite, who left her beached in Oyster Bay, where she eventually went to pieces. (Lillian Johnston.)

There wasn't always access by steamboat, and roads were rudimentary. On a Sunday excursion from Agate to Shelton in 1910, the Linton family convoyed their boats and rowed the three miles along Hammersley Inlet. If they had chosen to walk or take their wagon, even by today's linear highway, it is at least 10 miles. (MCHS.)

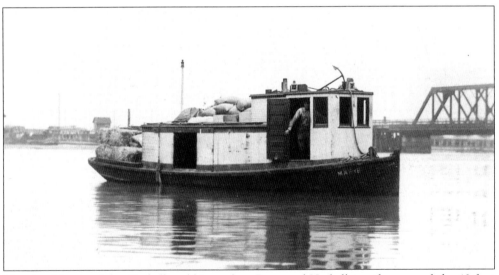

Harstine Islanders John Haskell and his nephew Raymond Haskell together owned the 40-foot launch *Marie* (pictured in Commencement Bay), which carried passengers and freight between Shelton, Olympia, and Tacoma. John Haskell was known for his sympathetic nature. If he saw someone running late to catch his boat, he would always turn back and pick them up. Later the Haskells owned the *Vixon*. (Lyle and Gene Carlson.)

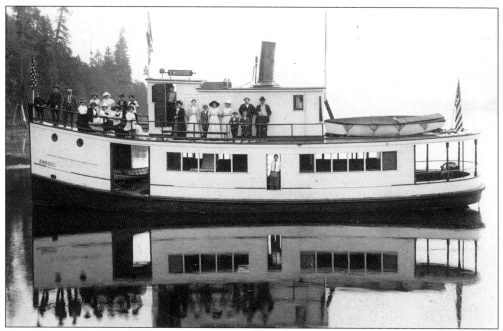

The 56-and-one-half-foot *Emrose*, built in Shelton in 1911 by the Munson Brothers for service between Shelton and Tacoma, carried freight and passengers. This route included stops at Longbranch and Steilacoom or Titlow. Later Miles Coffman bought her to use on the Tacoma–Wollochet Bay run. Her captains included Maurice Hunt and, in 1928, Tom Torgesen of Fox Island. The *Emrose* was abandoned in 1930. (MCHS.)

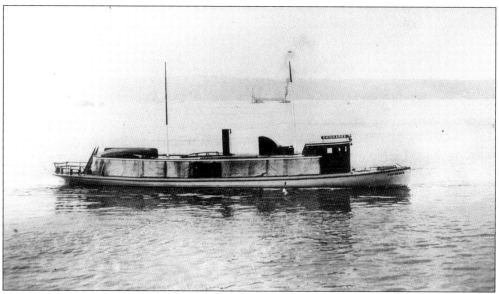

The *Chickaree*, named for the noisy western forest squirrel, was designed by Emmett Hunt, who gave her a modern, 100-horsepower, gasoline engine. The *Chic* was 74 feet and drew only 2.5 feet, giving her a low-slung appearance. In 1911, she was sold to a Captain Hopkins to replace the *Mizpah* on the route from Olympia to Oyster Bay and Kamilche. In 1942, she burned at Bremerton. (MOPS.)

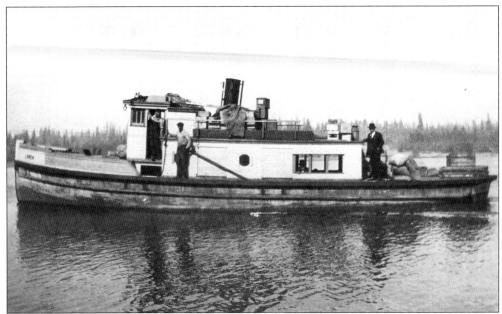

The U.S. Navy built the 54-foot *Loren*—probably not her original name—in 1914. When Glenn Harriman, shown at the wheel in Vaughn Bay, began his three-times-a-week service to Olympia in 1923, his family's youngest son, Loren, was a newborn, and the boat was likely renamed in his honor. Harriman made stops at Vaughn, Allyn, Harstine Island, and Squaxin Island carrying 25–30 passengers and produce. (GHPHS.)

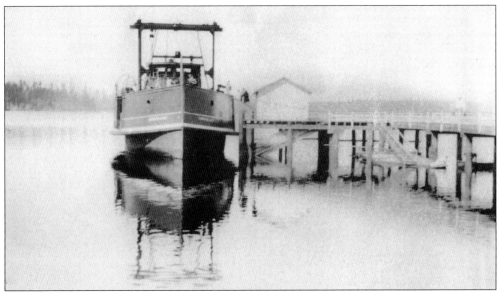

Rebuilt in 1927, the former stern-wheeler *K. L. Ames* became the diesel freighter *Skookum Chief*, shown at Eckert's Landing where there was a juice factory on Stretch Island. Also on Stretch Island, the St. Charles Winery now houses the Museum of Puget Sound. In 1922, Detroit, on the mainland by Stretch Island, renamed itself Grapeview in honor of the Island Belle grapes, a crop established in 1872. (MOPS.)

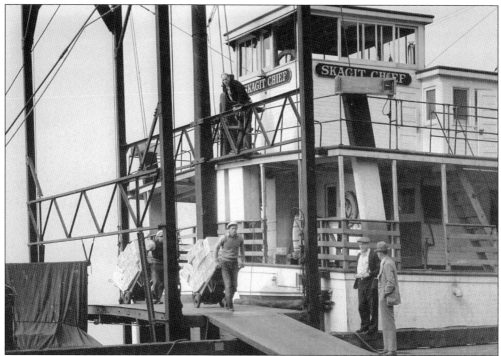

Invented in 1909 by Capt. Harry Barlow, the Barlow Marine Elevator was a much safer and faster way to load or unload a boat. Before this, a ramp that sloped between the dock and a ship's deck was used, and a man using a hand truck muscled a heavy load up or down. As shown above, the new elevator spanned the forward section of the boat in front of the wheelhouse, and a platform slid out almost level with the dock, no matter what stage the tide. The picture below shows an intermodal use of the ramp, which is being positioned between the *Skagit Chief* and a railroad boxcar. The first Barlow lift was installed on the *Fidalgo* in 1910, and by 1930, almost every freight-carrying vessel in the Mosquito Fleet had one.

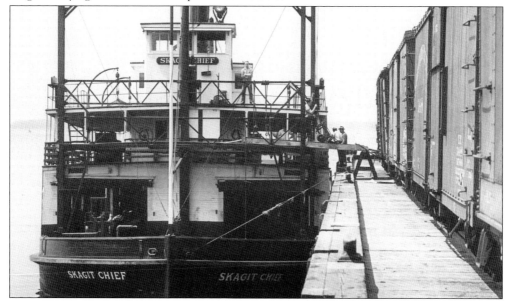

This view from Longbranch looks east across Filucy Bay toward Steilacoom and Mount Rainer. McNeil Island lies on the left across Balch Passage from Anderson Island. Drayton Passage divides Key Peninsula from these islands. On a foggy Tuesday, March 11, 1924, the *Fortuna* of Harstine Island, owned by Arthur Wingert, met the 40-foot, gas-powered mailboat *Edith H.* on her run from Allyn to Steilacoom, and they sailed together. However, *Edith H.* is best remembered not for this encounter but as the scene of a rare murder/suicide at 8:15 that morning. They had just rounded Devil's Head and entered Drayton Passage when passenger John Pearson, later described by his Herron Island neighbors as a recluse and who the pilot, Harry Shellgren, said was acting strangely, unaccountably stepped up behind Robert Tolstrup, the engineer and part owner of the boat, and shot him dead. He then shot himself and died three hours later at Western State Hospital in Steilacoom. No motive was ever learned. (Smith-Western Company.)

Three

BAY ISLAND

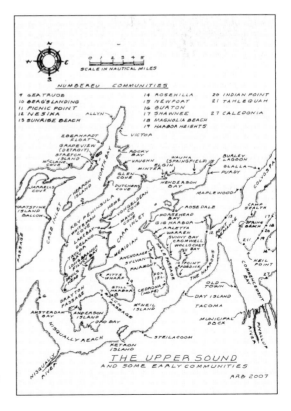

Bay Island is what the Hale Passage
farmers called this region when, in 1906,
they formed their cooperative, Bay Island
Producer's Union; bought their own
boat; and established a profitable way to
compete with growers across the state.
Bay Island is not found on the map but is
an apt designation for all the islands and
harbors on Carr Inlet that offered the
first settlers rich resources. Lumber, fish,
bricks, brush, produce, and commodities
all went to market, and supplies came in
on the return trips. Living in this remote
area was little different from living on
the mainland because, economically,
boats provided a convenient way to move
between homesteads and towns.

Miles and Marietta Hunt are pictured in the first row between their children Lillie and Forest with (second row, from left to right) twins Floyd and Lloyd, Arthur, Arda, and Emmett at their golden wedding anniversary in 1904. Miles homesteaded at the head of Wollochet Bay in 1875, sending for the rest of the family in 1877. Emmett was the first to have a marine career. In October 1881, he bought a mail contract for the run to Artondale on Wollochet Bay and built a 13-foot sailboat named *Alice*. She was an improvement over his rowboat, but complaints over late mail encouraged him to build a more substantial craft, and the 26-foot steamer *Baby Mine* was launched in September 1882. His diaries show she needed constant repairs, so by March 1884, he built her even larger replacement, the 31-foot *Gypsy Queen*, which he used for the next four years. Unfortunately, no photographs and only minimal descriptions of these boats exist. (GHPHS.)

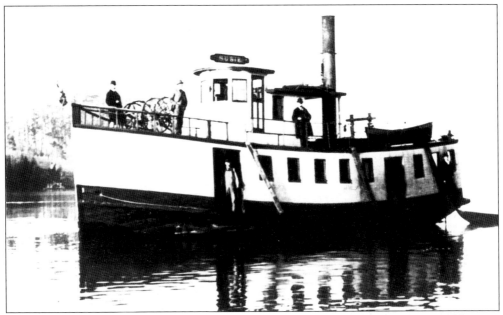

Fox Island Clay Works bought the *Susie*, built in Seattle in 1879 for Capt. Hiram Olney, in 1888 to haul their bricks and tiles and hired Emmett and Arthur Hunt as skipper and engineer. Besides hauling for the brickyard, the Hunts undertook many other jobs, including a contract with Tacoma for a daily disposal of garbage somewhere out in the Sound. In 1892, the Hunts purchased *Susie*. (GHPHS.)

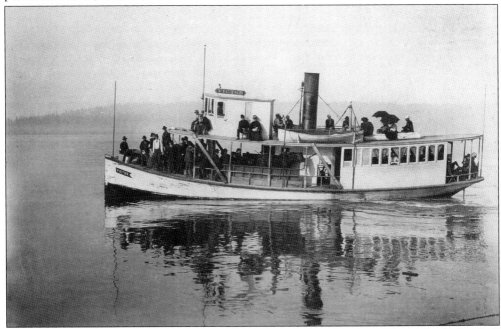

After *Gypsy Queen*, Emmett Hunt designed and had Haskell and Crawford build the 59-foot hull for *Victor*. Hunt and his brothers did the finishing. In spring 1893, the nation was going into a depression, and for the next five years, competition was heavy, though a mail contract in 1896 helped. *Victor* was sold in 1900 to make way for an even better Hunt boat, the *Crest*. (GHPHS.)

The German-born Lorenz family (Carl, a carpenter; Louise; and their children, Edward (left), Otto (right), Meta, and Oscar) homesteaded at Lakebay in 1882 where Carl established a water-driven sawmill that mainly provided lumber for local use. To deliver the surplus to Tacoma, Carl built a large scow powered with long oars but did not reckon with the winds and tidal currents through the Narrows and off Point Defiance. Its first and only trip took three weeks. Consequently, Carl designed and built *Sophia*, the first of a fleet that included *Meta*, *Tyconda*, *Typhoon (I)*, *Tyrus*, *Typhoon (II)*, *Thurow*, *Sentinel*, and *Arcadia*. The Lorenz boys all had boating careers—Ed as a captain, Oscar and Otto as engineers—and their sister, Meta, was said to be as capable a boat handler as her brothers. In the 1920s and 1930s, the sons tried some north Sound routes with other boats, most notably the *Monticello* and *Mohawk*. (Ronald and Constance Burke.)

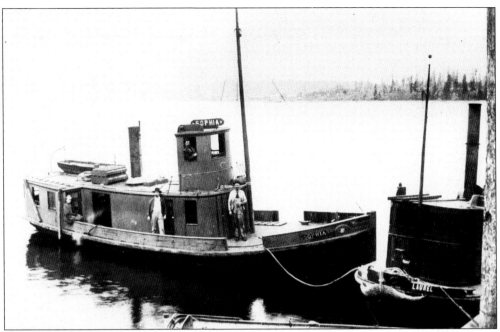

When Carl Lorenz needed a way to transport lumber to Tacoma, he designed and built the 42-foot tug *Sophia*, named for his mother in Germany and launched at Lakebay in 1884. Despite the lack of accommodations and having to climb over the cordwood when boarding, *Sophia* provided a needed passenger service. She was sold in 1890 to Frank Bibbins, shown standing in front of the pilothouse. (VMIHA.)

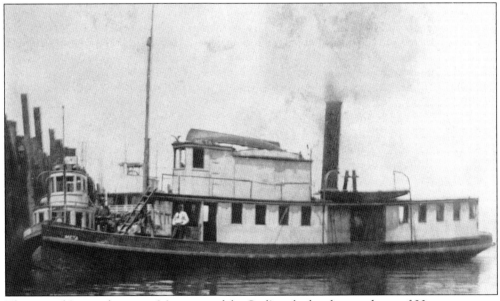

The second Lorenz boat was *Meta*, named for Carl's only daughter and one of 20 new steamers to appear on the Sound in 1888. The 58-footer replaced the smaller *Sophia* to accommodate the growing Tacoma–Henderson Bay route. In 1898, *Meta* was sold to Ainsworth and Dunn, converted to the tug *Grayling,* and, while being transferred to the Panama Canal, was lost off Coos Bay, Oregon, on July 25, 1909.

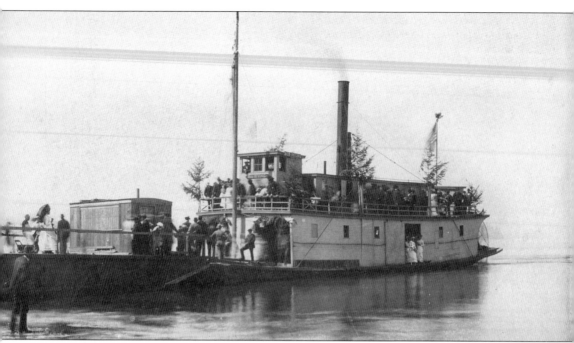

Named for her builder, the stern-wheeler *Bob Irving* was built in Tacoma in 1883 with a flat-bottom, shovel-nose design ideal for sloughs and shallows, so she first ran on the Skagit River. In 1884, she came south to serve on Tacoma–Henderson Bay and Tacoma–Quartermaster Harbor routes. An 1885 remodel enlarged her cabin enough for two square dance sets, making her the first boat in the area to hire out for such excursions. In this picture, she is decorated with Christmas trees for a Sunday outing in December. In July 1887, she was sold to Capt. Hiram Olney. Her machinery was removed and installed in *Clara Brown*; she was repowered with the engine from the *City of Quincy* and put back on the Skagit River. On April 1, 1888, going up Ball Riffles near what is now Sedro Woolley, her boiler exploded, destroying the boat and killing the engineer and Captain Olney, though three other crew members survived. (WSHS.)

Alfred Bismark "Biz" Burnham, son of Dr. Alfred Burnham who platted Gig Harbor in 1888, began his marine career in 1889. He was captain on the *Des Moines*, the little red *Zephyr* when it worked towing logs for the Tacoma Mill Company, the freighter *T. W. Lake*, Tacoma Tug and Barge's *Fairfield*, and the ferry *Defiance* before he retired to Vashon Island. (GHPHS.)

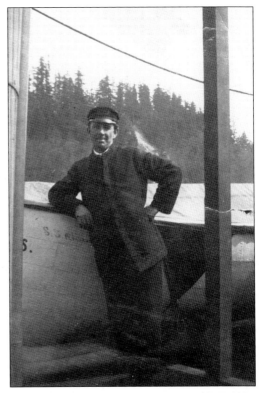

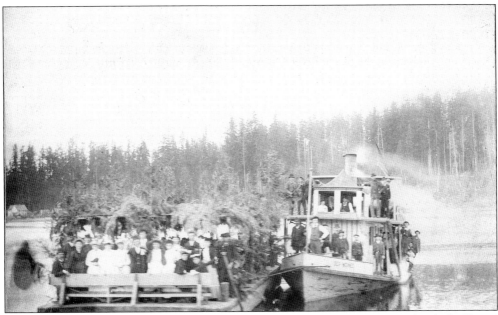

Built in 1889 and owned by Captain Burnham, the 49-foot *Des Moines* competed with the Hunts' *Victor* on the Tacoma–Gig Harbor run. Emmett Hunt called her "the Demon" as a cut-rate war developed and fares dropped to 10¢. Eventually the Hunts prevailed because the family of brothers worked share-and-share-alike while Burnham had to pay his crew whether they made money or not. (WSHS.)

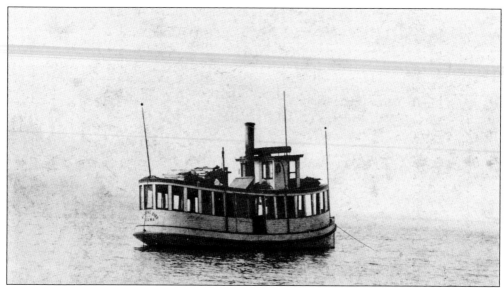

When the two warships *Baltimore* and *Charleston*, which had previously been in Portland for the 100th anniversary of the discovery of the Columbia River, visited Tacoma in June 1892, many boats did a brisk business carrying sightseers. In the ensuing rate war, the 31-foot *Mocking Bird*, above, along with the *Susie* and *Des Moines*, not only reduced fares to 10¢, but carried ladies and children free.

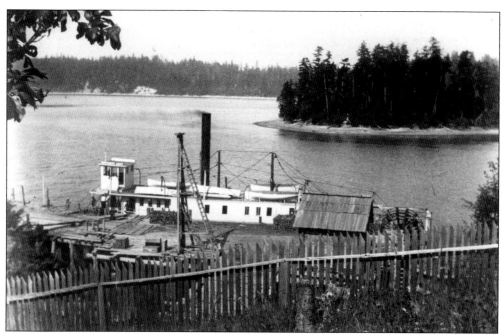

Anderson Island, the southernmost Puget Sound island, lies four miles from Steilacoom. In the late 1800s, it boasted two wood yards, Christensen's and Johnson's Landing. Unfortunately, because they were within a few hundred yards of each other, Johnson's survived and Christensen's did not. Between them, thousands of acres of timber were logged to fuel steamers such as this one, *Northern Light*, pictured at Johnson's Landing about 1890. (AIHS.)

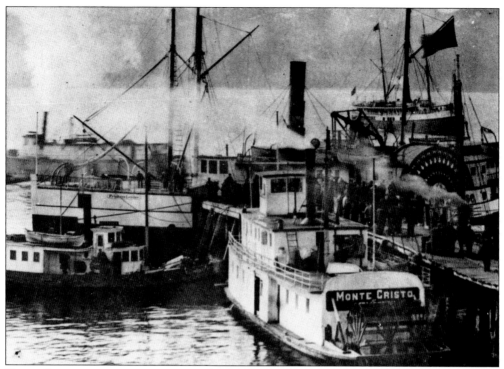

Henry Carstens, at one-time a purser for Oregon Railway and Navigation Company, had the 90-foot *Monte Cristo* built in Everett in 1891 for the Snohomish River trade. In 1893, grocery store owner and postmaster Ernest Shellgren of Longbranch bought her for freight, passengers, mail, and sometimes Sunday afternoon cruises. Shellgren sold her in 1896. She was abandoned in 1922. (KPHS.)

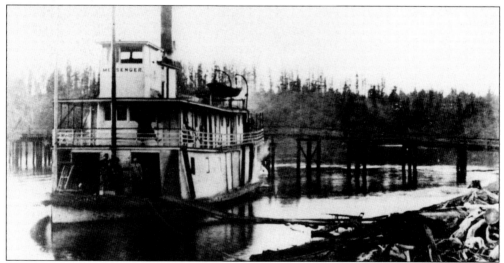

In 1891, the tireless *Messenger* called three times a week at Gig Harbor, Hume's Place, Sylvan Glen, Picnic Point, Artondale, Powell's, Fox Island, Delano, Lakebay, Balch's Cove, Minter, Springfield, Amoca, Rosedale, and Purdy, where she is shown drawn up to the beach unloading freight next to the original wooden bridge to the sandspit. Two days a week, she went to Meridian Brickworks, Shettleroe Bay, Vaughn, Detroit, Allyn, and Coulter Camp.

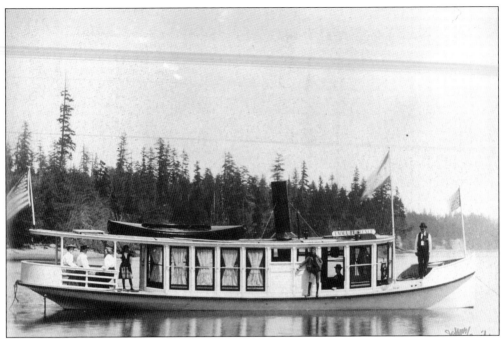

Named for his wife, the 50-foot *Emma Florence* was built in 1893 for Peter Dahlgreen of Anderson Island. During the mid-1890s depression, he lost the boat, which her new owner renamed *Marguerite*. Dahlgreen, a pattern maker by trade, went on to start a successful propeller-casting business, which he sold in 1916 to Puget Sound Iron and Steel Works. (Susan Parish.)

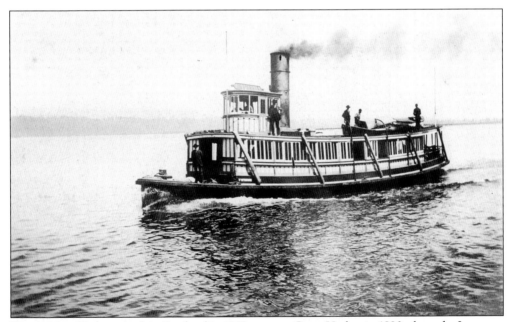

The 114-foot *Typhoon*, built in Portland in 1889, went to Grays Harbor in 1890 where the Lorenzes bought her in 1894. The first of their fleet of "T" boats, she was completely rebuilt before going on the route that included Tacoma, Hale Passage, Carr Inlet, and Henderson Bay under Capt. Ed Lorenz. In 1903, she was sold to Matthew McDowell for the East Pass. (FIHS.)

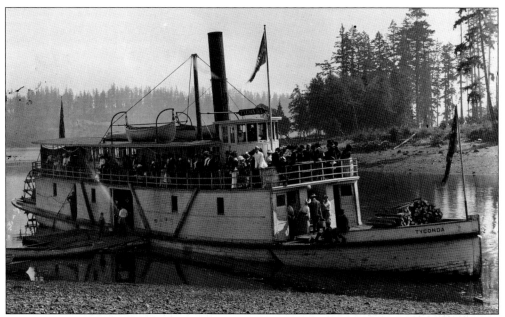

The *Tyconda*, built in 1898, was the only stern-wheeler the Lorenz family ever owned. With her shallow draft, she could land close to transfer freight at Cromwell, Sylvan, Warren, Arletta, Lakebay, and Vaughn and to board passengers, as shown on an excursion from Fox Island to Shelton in 1901. In 1914, she was sold for use on the Stikine River in southeast Alaska, where she burned in 1915. (FIHS.)

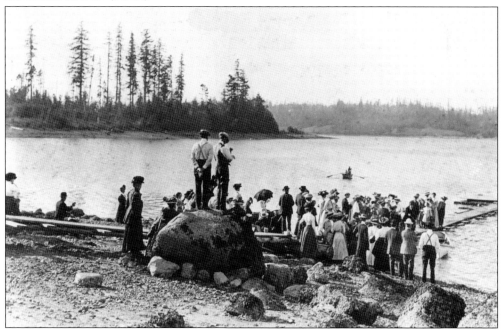

A 1901 excursion group on Fox Island's Boulder Beach awaits the annual outing sponsored by the Lorenzes. Even before settlers, Fox Island—originally called Batil Merman by the natives—had a fish-packing industry. After 1870, pioneers shipped bricks, flowers, and fruits. A prune drier began production in 1899 and a vineyard in 1924. (FIHS.)

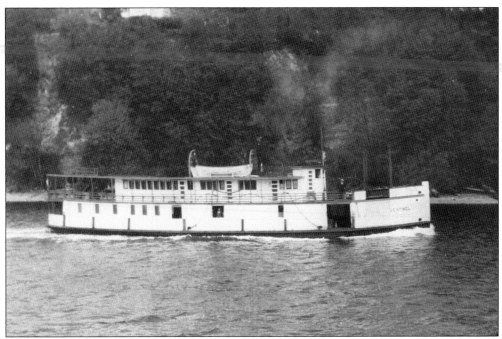

Haskell and Crawford built the slim, speedy *Sentinel* in 1898 for the Hunts, who used her locally in Bay Island and on a mail run to Seattle via Vashon, where she encountered stiff competition from both Matthew McDowell's *Defiance* and the first interurban rail from Tacoma to Seattle in 1902. She was sold to Hanson Transportation Company of Poulsbo in 1903 who sponsored (built out) her hull, giving her a chunkier appearance (see photograph below). She could then carry 250 passengers instead of just 100, but she was never again as fast as before. Ed Lorenz bought her in 1921, operated her for seven years, and then moved her machinery to the *Arcadia*. (Below MOPS.)

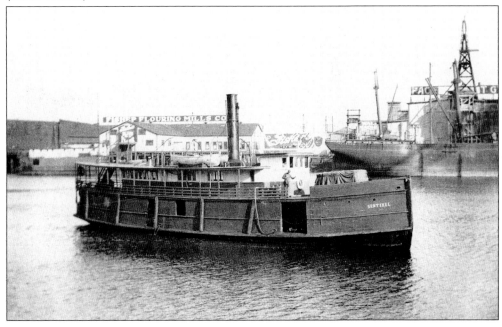

Home was founded as an experimental socialist cooperative on Von Geldern Cove, locally called Joe's Bay. Property was held by the association, and the only rule was they did not tolerate intolerance. Home had regular steamer service, was a center for social activities, and produced a measure of prosperity with the production of cordwood, fruit crops, poultry, eggs, and timber.

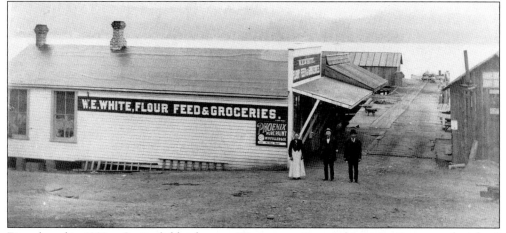

First platted in 1889 as Springfield, it became Wauna, a native word meaning "strong and mighty," chosen by postmistress Mary Frances White in 1906. In 1899, the Whites built their store on the upper side of the road, but because most of their business was from the water, they built this new building in 1906. It is shown next to the dock where Christmas trees and mine timbers were shipped. (KPHS.)

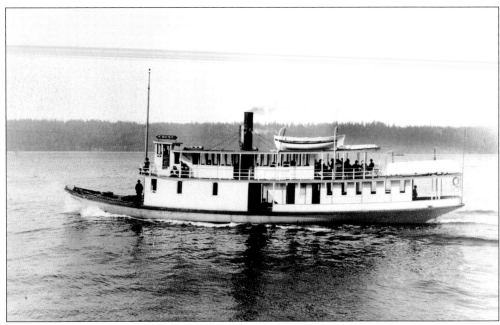

Designed by Emmett Hunt and built by Crawford and Reid in 1899, the 100-foot *Crest* (above) had a new teardrop shape meant to reduce drag. Though no faster, the design allowed her to carry more cargo at the same speed. Catching fire in September 1900, Arda Hunt scuttled her, thus saving the hull and engine, and she was back in service by April. In 1912, the Hunts sold *Crest* to the Bay Island Producer's Union, who renamed her *Bay Island* (below) and used her to deliver crops and commodities to market. She made 10 stops on her daily trip. Elmer Stone bought her in 1927 to use as a tugboat. She was destroyed in a storm while moored at Mukilteo in November 1928.

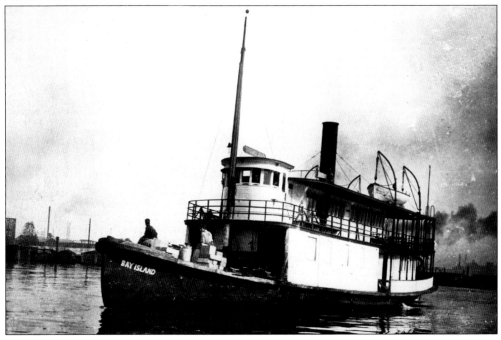

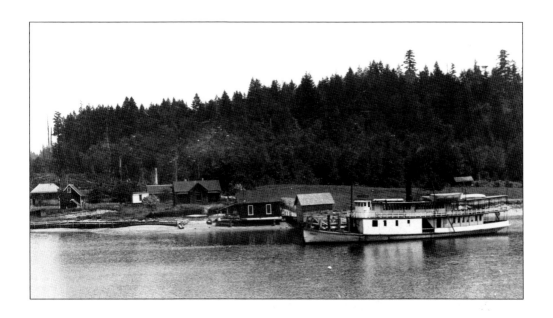

Logging, farming, chickens, and orchards were the economic mainstays of the Wollochet Bay area, and Miles Hunt, the first homesteader, established the Artondale Post Office at the head of the bay in May 1878. Picnic Point, across from Artondale, was a popular site for excursions. The first Bay Island Fair was held there in 1917. Two stores at Picnic Point had docks for their customers. Above, the *Tyrus* is moored at Picnic Point. Below, in a 1912 photograph, Anna Hunt, wife of Lloyd who was one of Miles's sons and a steamboat captain, rows along the shore as the *Bay Island* arrives at Picnic Point. Wollochet Bay, named for a native word meaning "squirting clams," was a Native American reservation until 1913. (Both GHPHS.)

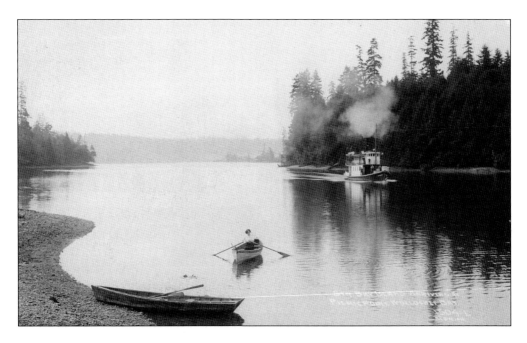

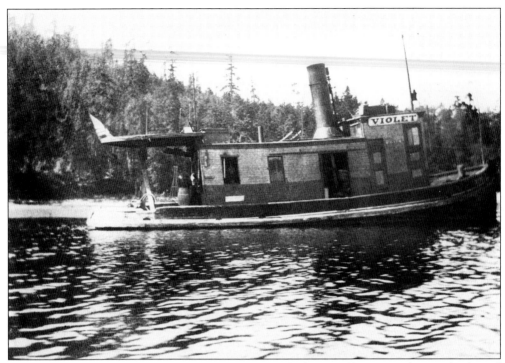

Several launches were shrimpers, an industry that flourished, especially near Anderson Island, until lack of restrictions hastened depletion of the supply. *Violet*, above, a 35-footer built in Seattle in 1887, had as one owner Gunnard Johnson, son of Bengt of Anderson Island's Johnson's Landing. The 52-foot *Trio*, below with her dredge on the stern, was built at Decatur by the Reid brothers as a shrimper and was owned by Paul Camus and John Anderson. She also fished in the San Juans and was later converted to a tug. Walter Larson, operating the *Orlou* from 1916 to 1931, was the last commercial shrimp fisherman from Anderson Island. Other south Sound shrimpers were *Alta, Anna B., Audrey, Crescent, G'vasa, Louise, Magdalene, Marion A., Nellie Bly, Octoo, Queen, Rover, Starling, Viola,* and *Zebeta*. (Above GHPHS; below AIHS.)

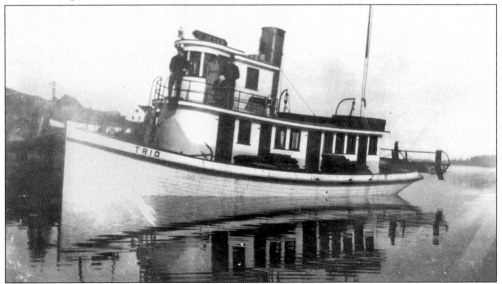

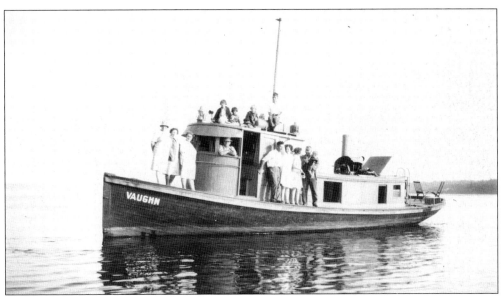

Isolated communities depended on floating stores. Ernest Ehricke began in 1906 by operating the *Bertha* for Raisoni's Store on Case Inlet. On his way to Raisoni's with a load of freight from Tacoma, he swamped in a gale off Vashon Island and had to swim ashore. Undaunted, he bought the new 45-foot *Vaughn*. On a twice-a-week route, Ehricke picked up goods for market and sold staples and sundries. Among other store boats were *Fernacre* and *Fernacre II* used by George Pierce of Fox Island to make deliveries along Hale Passage. From 1912 to 1918, Richard Uhlman was the south Sound's floating butcher. He could run his boat *Butcher* onto the beach and lower a gangplank for his customers. (Above Cindy Haugen; below Ron Karabaich.)

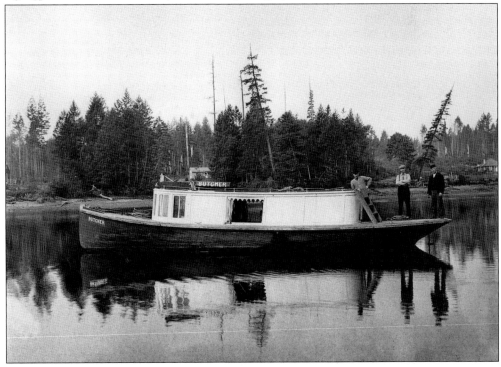

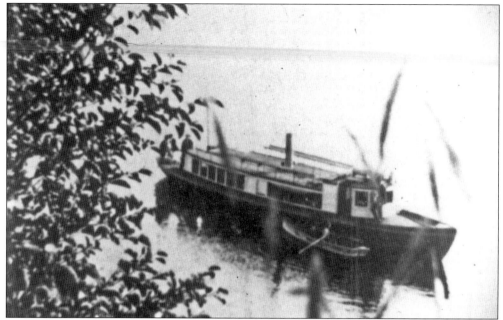

In 1900, Glen Elder and *Eagle* (above) began twice-a-day passenger, freight, and mail service to any place there was a float or rowboat between Steilacoom and Longbranch. In 1910, he had the larger, 49-foot *Eagle II* built by William Sipple. In an accident during a 1907 Christmas-season storm, the landing float at Steilacoom broke, dunking 25 passengers who were wet but otherwise unharmed. (GHPHS.)

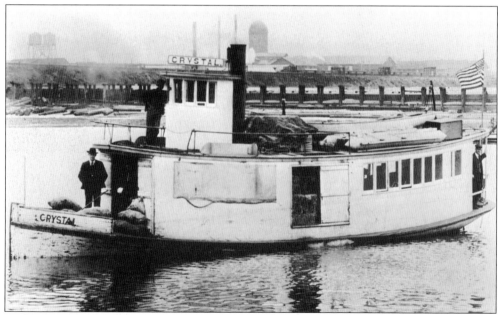

Little *Crystal*, 45 feet long and 25 tons, was built at Gig Harbor in 1904 for Miles Coffman, who operated her between Tacoma and Wollochet Bay, carrying passengers and produce and taking occasional excursions. She was replaced by *Audrey* in 1909, given a gasoline engine, and sent to Port Angeles. (PSMHS 1065-1.)

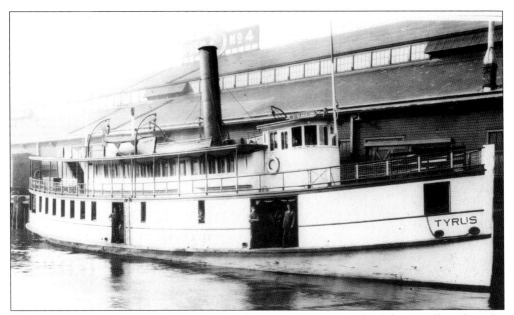

The Lorenz family added the *Tyrus* to their fleet in 1904. Built at the John J. Hill yard on the Puyallup River, the 108-footer received her machinery from *Typhoon (I)* but in 1906 got a new triple-expansion engine, which was later transferred to the *Virginia V* and still runs 100 years later. *Tyrus* ran three times a week, then daily, to stops on Case and Carr Inlets.

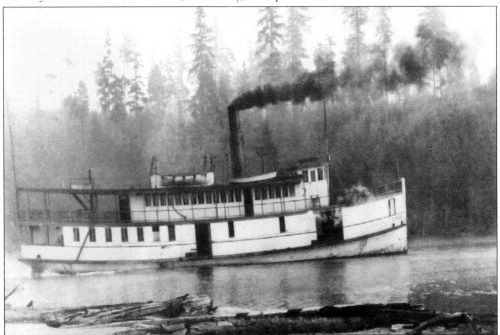

In 1896, Balch's Cove, probably named for Steilacoom pioneer Lafayette Balch, was changed to Glen Cove, shown in 1904 with the *Tyrus* departing. The community began as a logging site, and later there were brickyard and brush cutting businesses. A three-story resort hotel, operated from 1897 to the 1930s, has reopened as the Olde Glencove Hotel and is listed on the National Register of Historic Places. (KPHS.)

Settled in 1882 and named for the first postmistress, Minter lies near the mouth of Minter Creek, about three miles south of Wauna. The first industry was logging, but as the land was cleared, logging gave way to farming and fruit growing. The *Tyrus*, shown in 1910, is pulled up to the Minter dock. The *Tyrus* was sold to Nels Christensen in 1918 and renamed *Virginia IV*.

Gig Harbor, named by the 1841 Wilkes expedition because there was enough depth for small vessels or gigs, lies across from Point Defiance, right before the Narrows entrance. Guarded by a sandspit, the harbor has been home to a fleet of fishing boats—the foundation of the economy. Shipbuilding and other industries ensued. The *Chickaree* is moored at the dock, which looks toward the sandspit in this 1907 photograph.

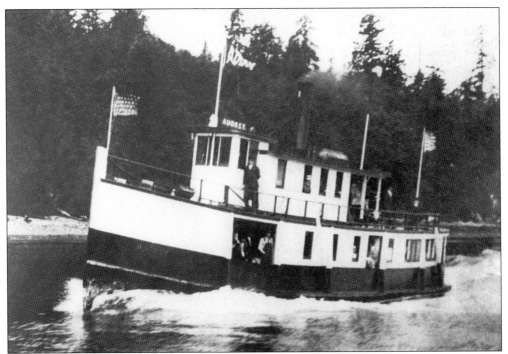

Built in Tacoma in 1909, the 65-foot *Audrey* (above) replaced *Crystal* on the Tacoma–Wollochet Bay run. Shelving replaced her original luxurious fittings of brass spittoons and walled railroad lamps when she became a grocery boat serving Still Harbor, Anderson Island, Longbranch, and North Bay. Converted to a tug, she was sold in 1943 to Delta Smyth and then in 1960 went with all Smyth tugs to Foss. (PSMHS 554-1.)

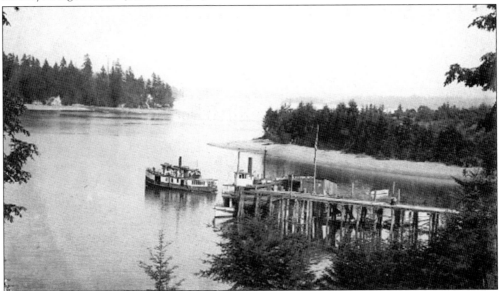

Longbranch, shown with the *Audrey* leaving and the *Tyconda* at the dock, lies on Filucy Bay. In 1887, William Sipple opened a carpentry and shipwright business where he built houses, tugs, launches, and other small craft. Although it was never lit, he also constructed a handsome lighthouse in 1915 at the entrance to Filucy Bay. Eventually it was vandalized and burned down. (KPHS.)

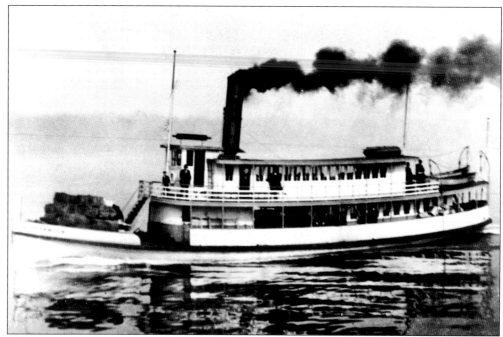

The Lorenz brothers added a new *Typhoon* in 1910, making a fleet of three "T" boats with the *Tyconda* and *Tyrus*, their first *Typhoon* having been sold in 1903 to Matthew McDowell. She was a nice-sized boat at 93 feet long with a 19-foot beam. After only four years, she was sold to Nels Christensen, who rebuilt her as the *Virginia III*.

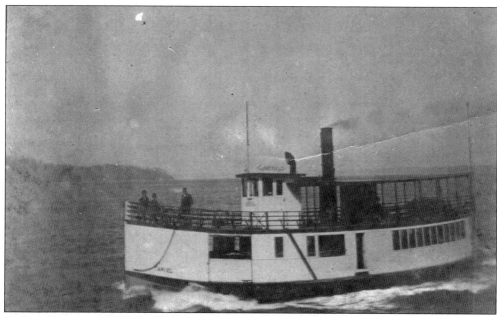

Built in Tacoma in 1912, the 58-foot *Ariel* was the last passenger boat in service to Allyn. For a while, the Hunt brothers ran her, but in 1919, declining business ended their partnership, and she was sold. The *Ariel* continued carrying passengers Tacoma-Allyn until 1924, then she left to become a commuter vessel on Lake Washington until 1945. (MOPS.)

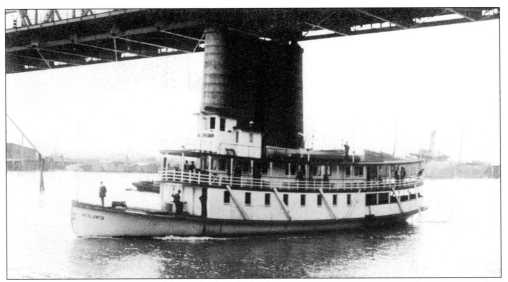

The 112-foot *Atalanta*, above at Tacoma, was the last passenger steamer on the Tacoma–Gig Harbor run and the first south Sound steamer to carry cars in the pre-ferry era, though they had to be loaded like cargo. The Hunts had her built in 1913 at Marine Supply in Tacoma to replace *Crest*. With her 500-horsepower, five-cylinder, triple-expansion steam engine, she cruised at 16 knots. She later served Whidbey-Seattle.

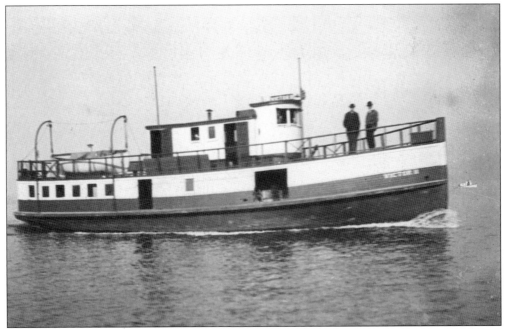

The 61-foot *Victor II*, built at Maplewood in 1914, worked Tacoma–North Bay. Two Fox Island children drowned when she capsized off Point Defiance during a January 1924 northeasterly gale while carrying a top-heavy cargo of lumber, throwing her load and eight passengers into the water. The boat was raised and rebuilt as a tug by Delta V. Smyth. (PSMHS 5689.)

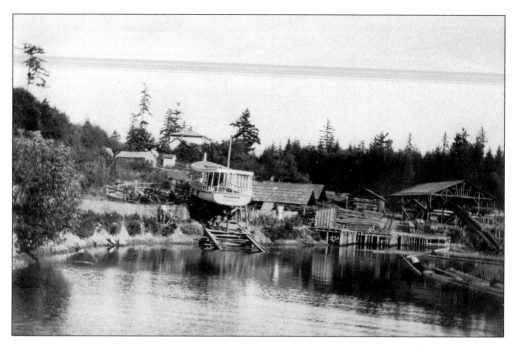

Named for their mother's German hometown and shown above ready to launch at Lakebay in 1918, the 45-foot *Thurow* was built by the Lorenz brothers with a unique pilothouse control of a gas engine. This arrangement soon proved problematic, so the boat was retrofitted with traditional steam. In 1919, her captain was Ed Lorenz's friend Bert Berntson, who at this time was using his own boat, *Leah M.*, to deliver freight on weekends. Eventually the *Thurow* became too small to handle the increasing business and about 1927 was sold to Horluck Transportation, who gave her a diesel engine and used her for Bremerton–Port Orchard commuter traffic. She was scrapped in 1945. Below, the pert *Thurow* gets underway.

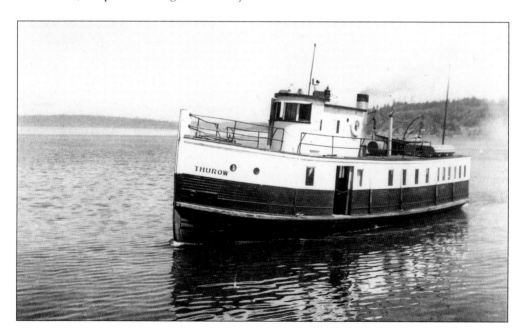

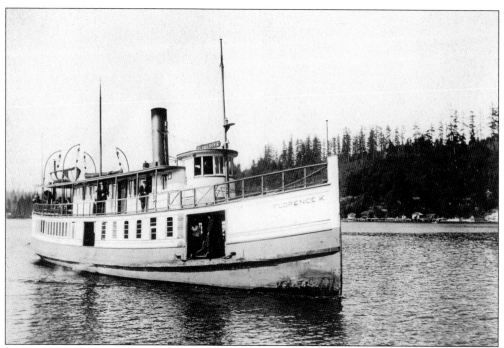

The 93-foot *Florence K.*, above, was built at Crawford and Reid in 1903 for north Sound service. In 1919, Arda Hunt acquired her from his brothers when their company dissolved, and he put her on the Gig Harbor run. While on their daily routes, steamboats often raced. If they won, it was good advertising and a way to attract more customers. The races were informal—two boats would meet, one captain would blow a whistle in challenge, and they were off. Exciting for the passengers, it often enlivened the tedium of an ordinary passage. Below, passing Point Defiance, the *Sentinel* (left), deemed to be a speedy boat, lags behind the *Florence K.*

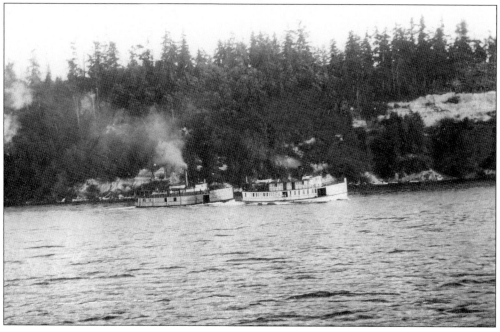

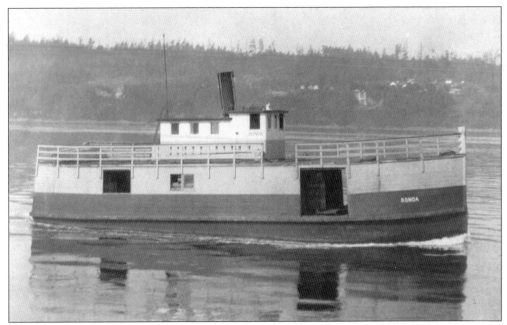

The steam freighter *Ronda* had at least 10 different owners, among them W. C. Wright (Gig Harbor), Capt. Tom Torgesen (McNeil Island), Vern Christensen (Vashon Island), and Lloyd Hunt (Gig Harbor). Built in 1922 at Gig Harbor, she hauled produce to Tacoma from Case and Carr Inlets. She was only 58 feet, but in a fog, her loud melodious whistle installed from the *Magnolia* could intimidate many a larger vessel.

McNeil Island is perhaps the best known of the Puget Sound islands because in 1870 the oldest federal penitentiary was established here. Once there were three mail stops: Meridian on the northwest shore, soon moved across Pitt Passage to the mainland; Bee, by the penitentiary on the south side; and Gertrude, on the northeast at Still Harbor where the *Emrose* is landing. (AIHS.)

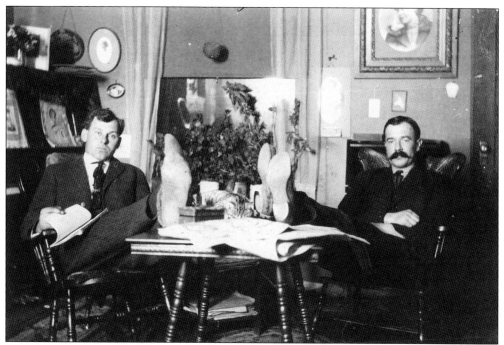

Miles Coffman (a grandson of pioneer Miles Hunt), shown above left relaxing in his home with his brother Percy, went to work at age 14 as a cook on the steamer tug *Laurel*. Other jobs followed: deckhand, oiler, engineer, and captain. One boat he owned was the sturdy *Emrose*, built in 1911 and seen all over the south Sound from Shelton to Gig Harbor. On one memorable occasion in December 1924, after weeks of heavy rain followed by a cold snap, the *Emrose* froze in the ice in Gig Harbor, pictured below. Fearing the ice would compromise the caulking and sink her; Coffman fired up the engine and, using the propeller to churn the water, broke her way to freedom. The *Emrose* did sink, but not until June 1929 in the Lake Washington Ship Canal. (Both GHPHS.)

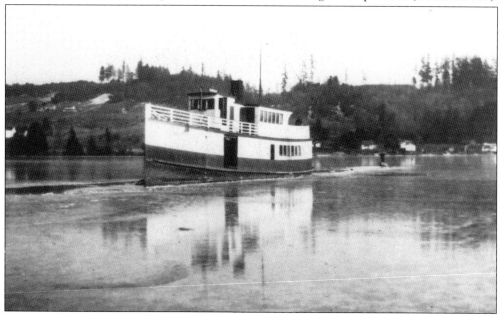

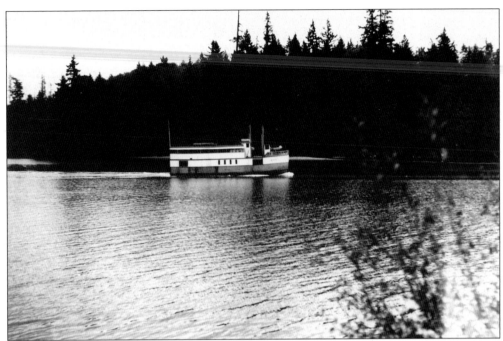

Named for the strong pack animal, the 53-foot *Burro* with her Barlow lift was built in Gig Harbor in 1922 for Floyd Hunt as a passenger, mail, and freight boat, shown delivering to Lakebay. Hunt sold her after his son, Ward, fell overboard and drowned in 1926, but the boat continued in service until 1956. In 1961, she was rebuilt as the excursion boat *Carolyn* M. (KPHS.)

Leah M., a launch owned by Bert Berntson, is best remembered for the years 1910–1915 when she hauled hundreds of strawberry flats from Fox Island to Tacoma markets. Berntson also worked on the *Bay Island, T. W. Lake,* and *Multnomah*; partnered with the Lorenzes on *Thurow, Sentinel,* and *Arcadia*; served on the ferries *Defiance, Skansonia,* and *City of Tacoma*; and in 1947 bought the *Burro.* (Ronald and Constance Burke.)

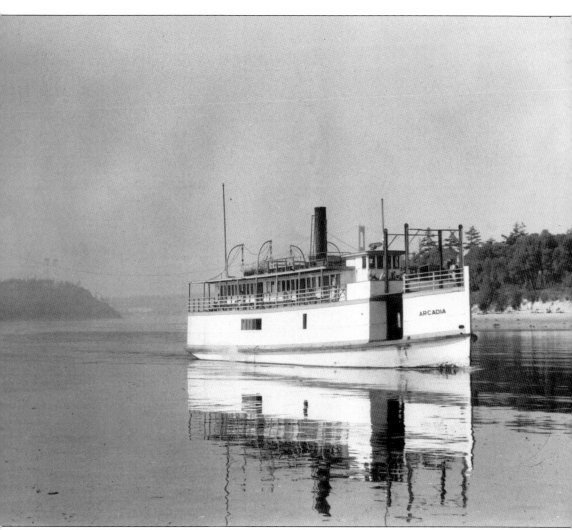

Captains Ed Lorenz and Bert Berntson had Mojean Ericson Shipyard in Tacoma build the 99-foot *Arcadia* in 1928. Able to carry 275 passengers and 100 tons of freight, she left Lakebay daily for calls at Home, Arletta, Anchorage, Warren, Sunnybay, Cromwell, Sylvan, Wollochet, Cedrona, and Tacoma. She is pictured above in her prime on her way south from the Narrows. In 1941, she was sold to the McNeil Island Federal Penitentiary, which changed her name to *J. E. Overlade* to honor a former warden, and she served another 15 years as a prison supply boat. In 1958, she became an excursion boat for the Puget Sound Excursion Company and was renamed the *Virginia VI* to identify her with her sister-in-cruises, the renowned *Virginia V.* (MOPS.)

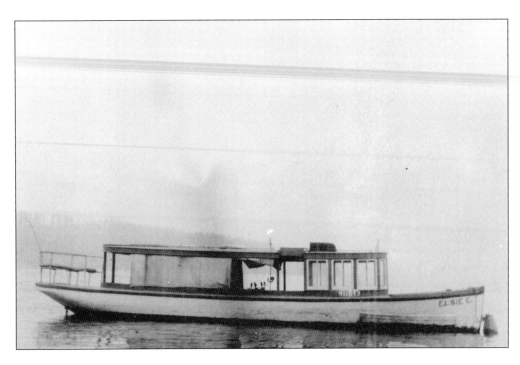

Elsie Claussen was one of few women to operate a steamboat on Puget Sound. Her father, Herman, owned the launch *Elsie C.*, above, and then at his death in 1930, she took over his second launch, *Elsie C. II*, which ran between Point Defiance and the three Sunrise Beach docks near Gig Harbor. Claussen ran the business successfully for four years until the boat burned in 1934. She then ordered a 56-foot replacement, *Elsie C. III*, which she took on its trial run in March 1935, but she died in April before it went into service. The boat was sold to Henry Moller of Gig Harbor, who continued the route until the mid-1940s. Below, Captain Moller lands the *Elsie C. III* at Sunrise Beach. (Both GHPHS.)

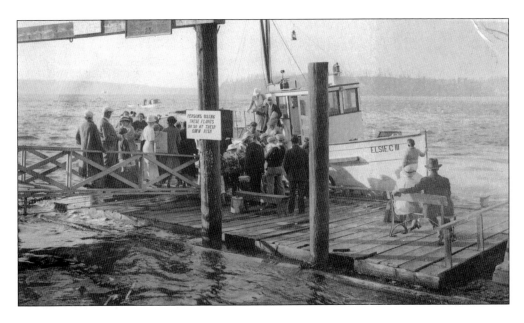

Four

VASHON-MAURY ISLAND

The first permanent settlers did not arrive on Vashon-Maury Island, named by Capt. George Vancouver in 1792, until 1877. According to an 1874 Tacoma newspaper, the *Weekly Pacific Tribune*, the island's commercial enterprises included fishing and logging. A brickyard was in operation by 1883. First settler Salmon Sherman, with his 32-foot, wood-burning steam launch *Swan*, began a Quartermaster Harbor–Tacoma service in 1883, and in 1884, the stern-wheeler *Bob Irving* also began stopping weekly. Since all communities developed on or near the water, soon other steamboats began routes along Colvos Passage (also known as West Pass), East Passage, and into Quartermaster Harbor. Before most of the landings were taken down in the 1930s, there were more than 30 docks.

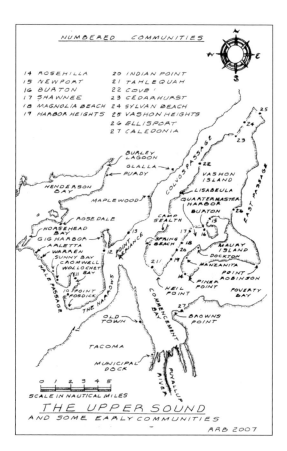

NUMBERED COMMUNITIES

14 ROSEHILLA
15 NEWPORT
16 BURTON
17 SHAWNEE
18 MAGNOLIA BEACH
19 HARBOR HEIGHTS
20 INDIAN POINT
21 TAHLEQUAH
22 COVE
23 CEDARHURST
24 SYLVAN BEACH
25 VASHON HEIGHTS
26 ELLISPORT
27 CALEDONIA

SCALE IN NAUTICAL MILES

THE UPPER SOUND
AND SOME EARLY COMMUNITIES

ARB 2007

In 1883, Salmon Sherman, one of the first permanent settlers on Vashon Island, bought a newly built, 32-foot, wood-burning steam launch that could carry six passengers called the *Swan*. Shown above, left, at anchor on Quartermaster Harbor with a native canoe near the shore, the *Swan* provided one of the first passenger services to Tacoma with two trips per week, depending on weather and wood supply. (Gene Sherman.)

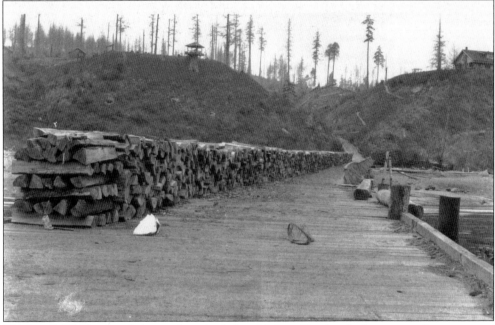

The bare hill behind and the cordwood piled on Vashon Heights dock attest to the amount of timber that went into steamboat furnaces. With a cord measuring 4 feet high by 4 feet wide by 8 feet long, it took prodigious amounts to fuel a stern-wheeler. Even a more efficient propeller boat, like the *Flyer*, burned 24 cords on her four round-trips daily between Seattle and Tacoma. (KCA.)

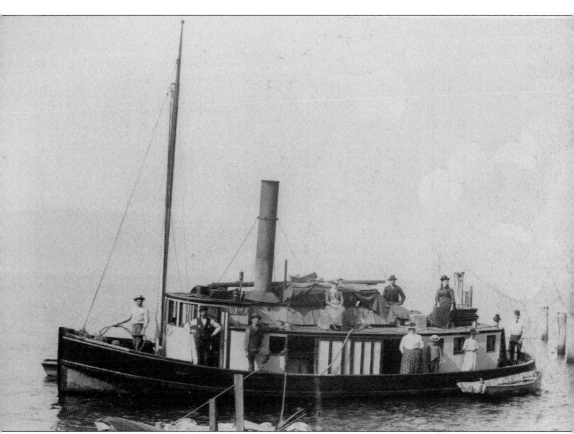

When Capt. John F. Vanderhoef became master of the *Iola* in June 1887, he remodeled the after cabin into living quarters for himself and his wife. One foggy morning on the West Pass, Mrs. Vanderhoef left the pilothouse saying she'd prepare lunch after readying the cabin. In shaking a tablecloth over the side, she fell overboard. She was neither seen from the pilothouse nor heard over the engine noise and was not missed until the boat reached Seattle. The captain's only choice was to retrace his path. Meanwhile, kept afloat by the air pockets trapped in her voluminous skirts, Mrs. Vanderhoef's cries for help were heard by Thomas Redding (who in a couple of years would buy the *Iola*), who was working on the beach at Cove. When her husband arrived, Mrs. Vanderhoef was cold, but safe and nearly dry. He is said to have remarked, "I thought for sure the Devil had her." (VMIHA.)

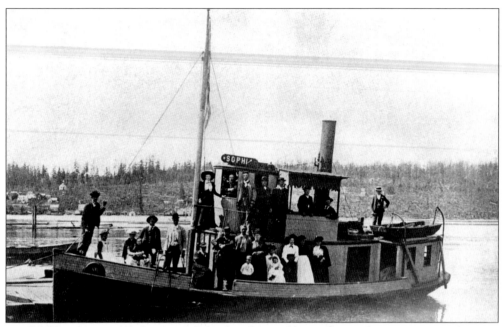

Frank Bibbins homesteaded on Maury Island in 1884 and by 1890 started a transportation business on Quartermaster Harbor that he operated for the next 18 years. He bought the 42-foot *Sophia* from the Lorenzes of Lakebay, and in 1895, Chauncey "Chance" Wiman joined him as captain and half-owner. This photograph shows Bibbins standing on the deck below the pilothouse behind the small boy in the white shirt. (VMIHA.)

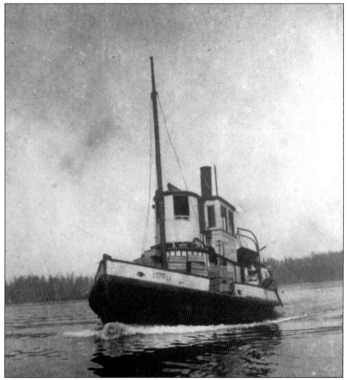

Navigation required skill and ingenuity to negotiate hazards like currents, darkness, and fog. Captain Wiman trained his dog to stand on the dock and bark in response to his whistle during fog. Once, however, a customer, annoyed by the barking, chased the animal off the dock and, in a testament to his ability, Wiman followed the animal's signal unerringly and piloted the *Sophia* right onto the beach. (VMIHA.)

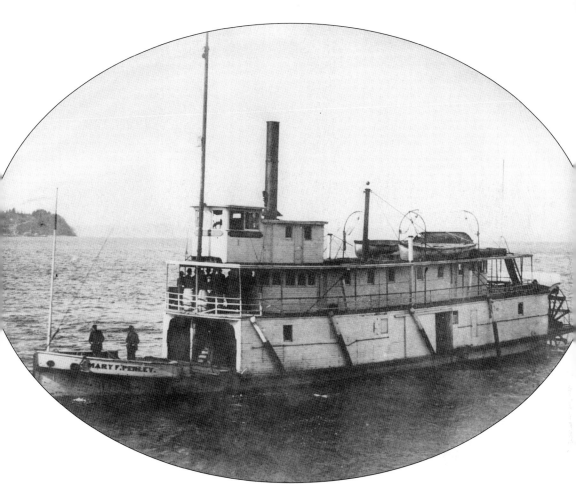

The 104-foot *Mary F. Perley*, built in 1888 by Capt. Henry Perley and the Dean Brothers of Samish and named for Perley's daughter, was a boat dogged by disaster. Bought by Thomas Redding in 1892 to carry mail along the West Pass, she had her stern-wheel severed by the *Flyer* in a dense fog off Alki Point that same year. In 1894, again in dense fog, Captain Redding was rounding West Point for Elliott Bay when she collided with the *City of Kingston*, though evasive action by both captains prevented a serious incident. In the ensuing lawsuits, both captains were exonerated, but in 1895, the *Perley* was sold to satisfy civil claims. A third collision with the stern-wheeler *Pilgrim* brought more lawsuits. Finally, in September 1901, the *Perley* was destroyed by a midnight fire that started in her engine room while lying off Alki Point. The crew all escaped unharmed. (PSMHS 5874.)

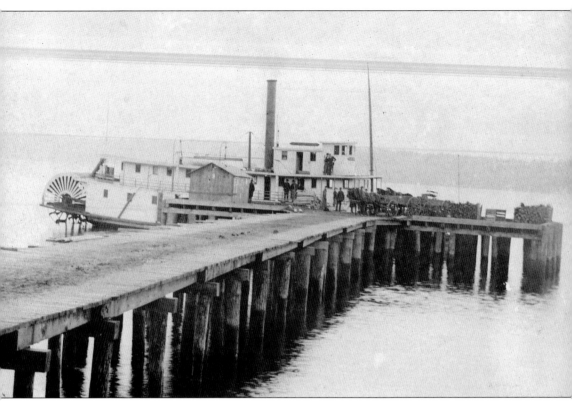

In 1892, Capt. John F. Vanderhoef put the 80-foot stern-wheeler *Glide* on a Seattle-Tacoma route, running the East and West Passes on opposite days. Billy Phillips, later a renowned master, was then still a deckhand whose job was to row ashore for passengers—and not make the boat late on her schedule. On the West Pass one morning, a rancher asked Billy to wait while his neighbor finished gathering a crate of eggs. Phillips replied, "Time and tide and the steamer *Glide* wait for no man." And she didn't. On the next trip, the egg man, still visibly upset, hailed the *Glide*, but on the return he was all smiles, for between the missed boat and the second trip, the price of eggs had gone from 9¢ to 12¢ a dozen. Captain Vanderhoef liked Billy's saying so much he tried to adapt it. He was once overheard telling a late passenger, "Time, tide and the steamer *Glide* will wait for no son-of-a-bitch on the West Side." (UW 19309.)

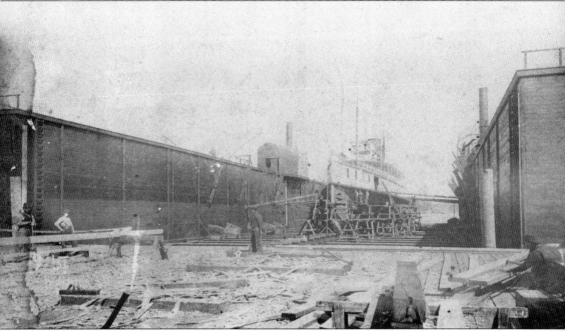

In 1891, M. F. Hatch of Burton formed the Puget Sound Drydock Company, had a dry dock built at Port Hadlock, and towed it, unfinished, to its location on the Quartermaster side of Maury Island. The first job at the 102-foot-wide, 325-foot-long, 8,000-ton structure, the largest on the West Coast, began in March 1892 when the *Flyer* (above), a boat too narrow to float steadily, was brought in for sponsoning out. Though not yet complete—the right-hand pump engine room had not yet been enclosed—it only took 30 minutes to lower the dock and another 30 minutes to raise her with the *Flyer* inside. Many crowds came to watch, excursions being handled by the *Sophia*, *Estella*, and *Glide*. By June, the dry dock, which gave its name to the community of Dockton, employed more than 80 men. Sold to John Heffernan, in 1909, the dry dock was towed to its new Seattle home. (MOPS.)

Matthew McDowell, shown here on his 93rd birthday, was born in 1850 in Northern Ireland. He came to the Northwest in 1888, finally settling at Caledonia near Brown's Point. Between 1898 and 1912, he built his seven "D" boats that dominated East Pass commerce. Perceiving cars would end the steamboat era, in 1918 and 1919, he sold his boats and retired. (Pts NE.)

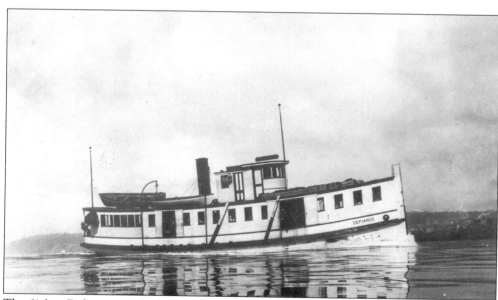

The 61-foot *Defiance* was the first of Matthew McDowell's "D" boats. Built in Tacoma in 1897, she was put into service on the East Pass, running Tacoma-Portage (Vashon Island)-Seattle in the morning and returning in the afternoon. Within a year, she was already too small for the amount of business and was replaced by the *Dauntless*.

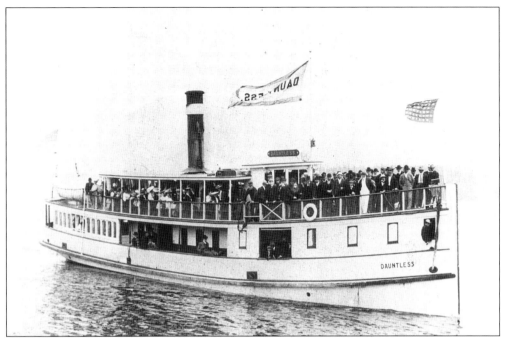

Again built in Tacoma, in July 1899, the second McDowell "D" boat, the 93-foot *Dauntless*, replaced the first *Defiance* on the East Pass route. Though business was good, she had competition from the Hunts' *Sentinel*, and in a rate war in October 1901, her fares dropped to 10¢. She was soon replaced by the second *Defiance* and sold to Moe Brothers for Bainbridge Island service. (MOPS.)

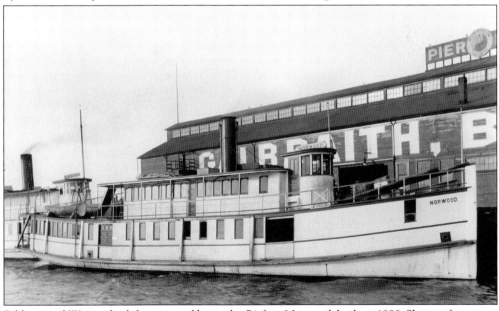

Bibbins and Wiman had their second boat, the 74-foot *Norwood*, built in 1899. She ran five years, twice a day, Quartermaster-Tacoma, and then in 1904, the partners fell out. Bibbins left and joined Arthur Hunt to form the Tacoma and Burton Navigation Company. Wiman sold *Norwood*, and he and John Manson of Dockton established Vashon Navigation Company. The *Norwood* sank at her Seattle moorings in 1924. (PSMHS 1787-6.)

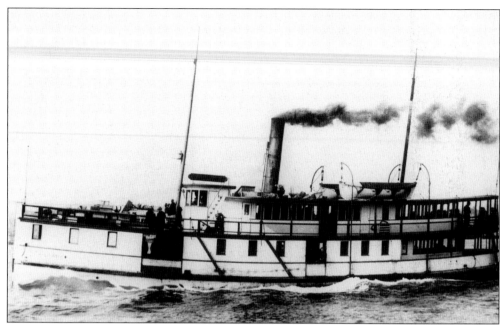

A second *Defiance* (above), McDowell's third "D" boat, was launched at Crawford and Reid in 1901, replacing *Dauntless* on her East Pass route. Another competitive boat, the *Vashonian*, collided with the *Dauntless* at Portage when both tried to be first into the dock. Sold to Kingston Transportation Company in 1913, she was immediately renamed *Kingston* (below) and put on the Seattle–Kingston–Port Ludlow route. Puget Sound Navigation bought her in 1917. Whidbey Island Transportation Company, in 1923, used her to re-establish steamboat freight and passenger service between Seattle and Everett. In 1933, a new owner converted her to diesel and outfitted her for trading in southeast Alaska, but she stranded and was lost near Sitka on her first trip. (Below MOPS.)

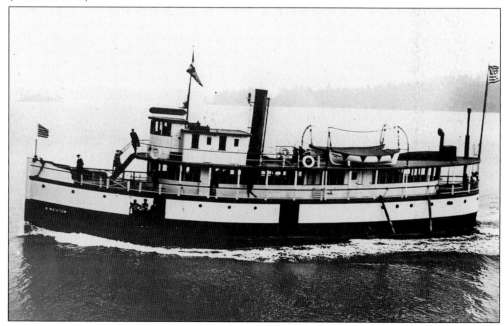

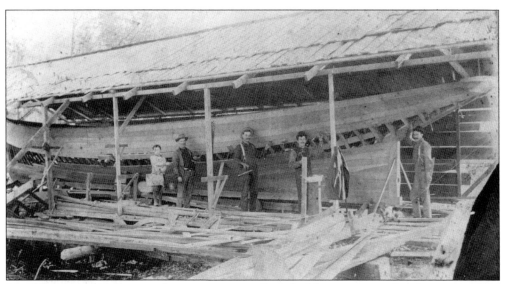

John Martinolich, a Croatian from an ancestry of boat builders, immigrated to America in 1896 and first worked at the Dockton dry dock. Martinolich Shipbuilding Company was launched in 1904 when he contracted to build the *Vashon*. In 1910, he built the *Verona*. With his reputation established, he thereafter built tugs, passenger steamers, yachts, and fishing boats noted for being the safest and most practical in the Northwest fleet. Martinolich retired in 1930, and the shipyard relocated to Tacoma in 1935. The workers in the top photograph, all family members, are, from left to right, Anthony Cosulich Jr., Anthony Cosulich Sr., Tom Lovrich, John Martinolich Sr., and ? Romey. At the bottom, standing beside the boat is Alexander Bussanich; seated from left to right are John Martinolich, John Cosulich, Billy Newton, ? Greer, Fred Harrison, and unidentified; an unidentified man perches above. (Both VMIHA.)

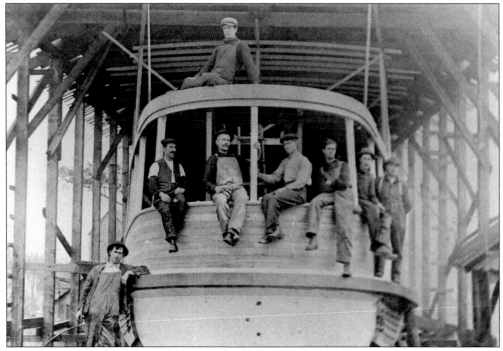

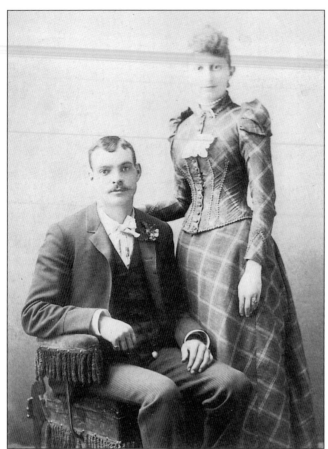

Married in the 1890s, both Chauncey "Chance" and Gertrude Wiman, shown in their wedding photograph at left, earned their master's papers. Gert's was the first woman's license on Puget Sound and second in the Northwest. Chance Wiman first partnered with Frank Bibbins in 1894, and after they parted, he and John Manson, a Dockton master and engineer, founded Vashon Navigation Company in 1905. (Richard Parker.)

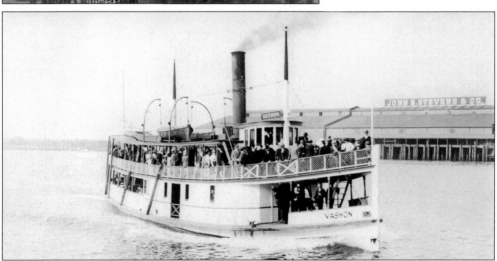

In 1905, Wiman and Manson's 94-foot *Vashon* was the first boat built at John Martinolich's shipyard. In June, her first race with the *Burton* ended in a dead heat, setting the pattern for their rivalry. Races, rate wars, even fistfights were common. Once the two boats raced for a cargo of sacked clams at Vashon Landing, and in the ensuing melee, all hands used all the clams as ammunition.

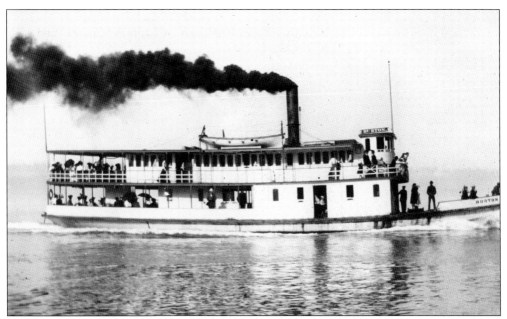

Arthur Hunt designed and he and Frank Bibbins built the 93-foot *Burton* (above) in 1905 to compete on the identical Quartermaster schedule as her rival, the *Vashon*. The two boats raced frequently, occasionally bumped, and several times the passengers and crews—the harbor passionately took sides—came to blows. After two years, the *Burton* was sold to Kitsap Transportation Company and served on all their runs out of Seattle until 1923. She was rebuilt in 1912, and her bow was enclosed to increase her cargo area. Note the K on the stack (bottom photograph), emblem of Kitsap Transportation. Sold in 1923, she had been left idle for nearly a year when she was destroyed by fire at her moorage in Gig Harbor. (Below MOPS.)

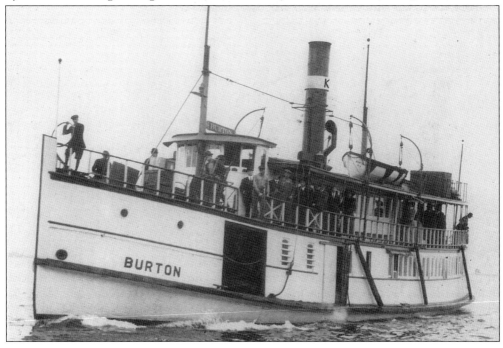

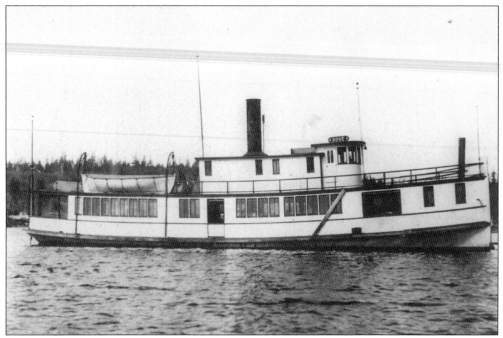

In 1904, McDowell bought the *Typhoon*'s hull and boiler from the Lorenz family and had her rebuilt at Crawford and Reid as his fourth "D" boat, the *Dove*. The 75-footer ran at 12 knots and carried 100 passengers. Billy Phillips served his first post as a captain on the *Dove*. She was sold to Merchants' Transportation in 1909 when the *Daring* was completed. (MOPS.)

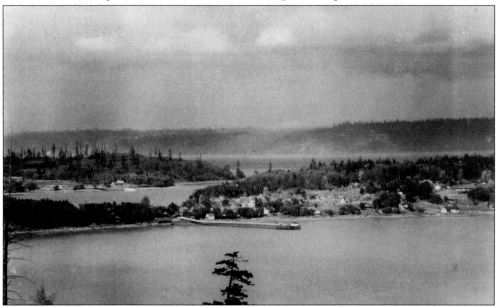

This panorama by Vashon photographer Norman Edson shows the 760-foot Burton dock, possibly the Mosquito Fleet's longest, extending into Quartermaster Harbor with Burton Peninsula on the right, Inner Quartermaster Harbor behind, and East Pass and the mainland in the distance. Built in 1894, this first public wharf acquired by King County was dismantled in 1955 and the pilings used for the Burton Marina and Yacht Club. (VMIHA.)

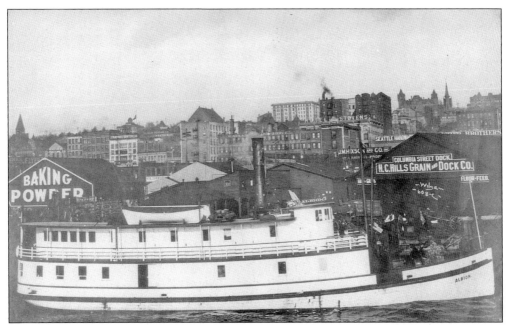

The 94-foot propeller *Albion*, above in Seattle, was built at Coupeville in 1898. In 1906, she was on a Tacoma-Seattle route, stopping at all West Pass landings. In 1924, she was damaged in an accident with the steamer *Chippewa*, whereupon she was converted to a combination cannery tender and fuel tanker to work among the fishing fleet off Cape Flattery. (MOPS.)

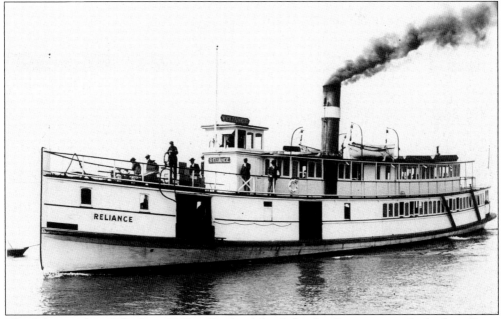

The *Reliance*, though built in 1900 at Portland for Columbia River service, had a long Puget Sound career, part of it on West Pass starting in 1906. The 118-footer ran a daily round-trip Tacoma–West Pass–Vashon–Harper–Seattle route. In November 1926, while moored in Lake Washington awaiting scrapping, she caught fire from the blaze that also destroyed the steamer *Bremerton*. (MOPS.)

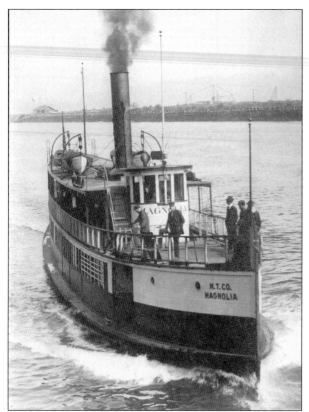

Built in 1907, the speedy 101-foot *Magnolia* began a 30-year career by replacing the *Burton*, including her role as the *Vashon's* racing competitor until the captains placed their boats on different schedules for the Quartermaster-Tacoma run. In 1909, Frank Bibbins retired and the *Magnolia* went to a direct Olympia-Seattle route and, after the *Nisqually* left, was the last steamboat to serve the capital.

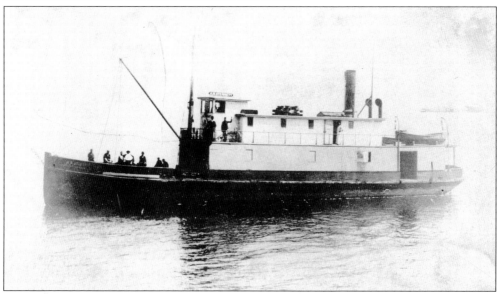

Rebuilt in 1905 from the Yukon tug *Anna E. Fay*, the freighter *A. W. Sterrett* served on West Pass. In 1910, she caught fire, was rebuilt, and in 1913 was rammed in a fog by the lighthouse tender *Manzanita*. Again repaired, she continued working until 1929 when all Merchants' Transportation Company boats went to Puget Sound Freight Lines, was laid up, and then beached in 1933. (WSHS.)

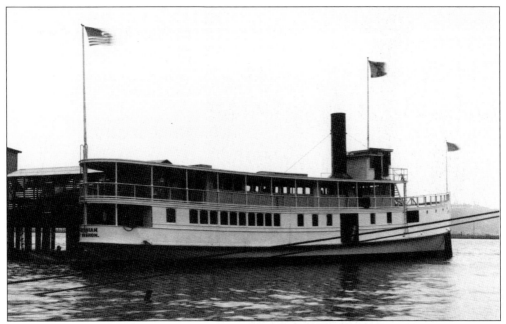

Vashon Steamboat Company had the 115-foot *Vashonian* built at Seattle in 1908. Unprofitable on the Seattle-Tacoma route, she was moved in 1910 to a mail run in the San Juan Islands. Again in financial troubles, Puget Sound Navigation bought her and renamed her *Puget*. She was later rebuilt as the ferry *Puget*. (MOPS.)

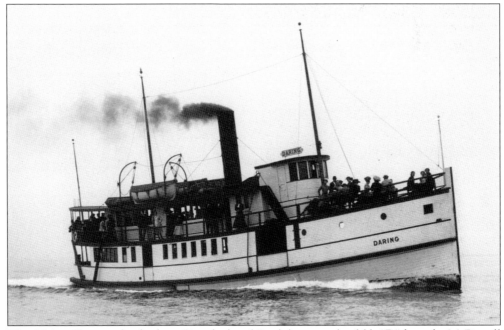

The 98-foot *Daring*, also built at Crawford and Reid, became the fifth "D" boat for McDowell in 1909 and ran on the East Pass route. Sold in 1916, she was a tug for Chesley of Seattle and then sold again in 1918 to Victoria owners where she was the tug *Clinton*. She was abandoned in 1923. (MOPS.)

The *Verona*, built in 1910 at Martinolich, was launched with the owners' wives— Anna Sophia Manson on deck holding the flag and Capt. Gertrude Wiman in her signature black in the pilothouse with an unidentified guest, right. The *Verona* was often in Gert's command, but not on Bloody Sunday, November 5, 1916, when her husband Chance sailed with 300 Wobblies to Everett for a free speech demonstration. Met at the dock by citizens and lawmen, a gunfight followed, Wiman taking refuge behind the boat's iron safe when a bullet ripped a spoke from the wheel. The boat tipped, many fell overboard, someone cut the bowline, and the *Verona* returned to Seattle with five dead and 31 wounded. In 1936, the *Verona* was destroyed by fire at her Seattle berth. (Left VMIHA; below MOPS.)

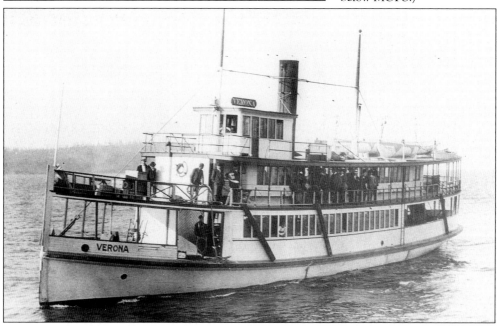

Nels G. Christensen ran a grocery store in Seattle until his doctor suggested country air. In 1908, he moved to Vashon Island and, in commuting, realized the need for timely transportation service. For 27 years, until his death in 1936, his West Coast Transportation Company was synonymous with dependability, fairness, integrity, and the name by which he called all his boats: *Virginia*. (VMIHA.)

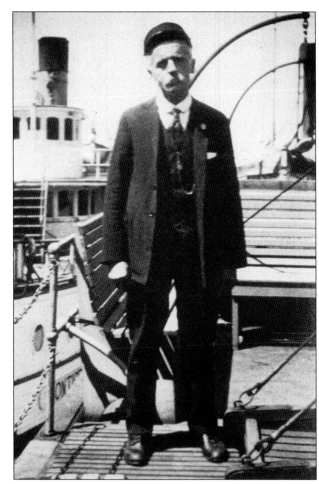

The 54-foot launch *Virginia Merrill* was built in Tacoma, 1908, for a logging company. In 1909, Nels Christensen and a neighbor formed West Pass Transportation and bought her for $5,000 to provide commuter service to Seattle. They dropped *Merrill* from the name and the *Virginia* dynasty was born when, carrying eight passengers, she made her first trip from Lisabuela to Seattle on September 10, 1910. (PSMHS 4329-1.)

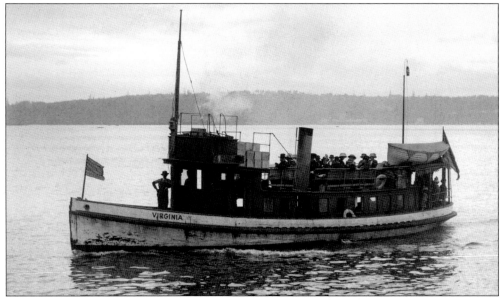

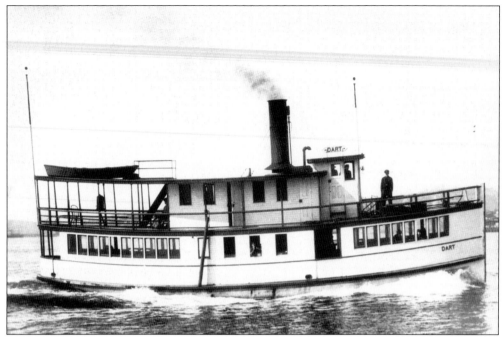

In 1911, McDowell added the sixth "D" boat to his fleet, the 57-foot, Tacoma-built *Dart*. She was sold in 1918 to Wrangell owners, who placed her on an Alaskan mail route between Wrangell and Prince of Wales Island. In 1925, she returned to Puget Sound as a tugboat. Burned in 1966, she was rebuilt as a diesel freighter for service at Juneau. (PSMHS 708.)

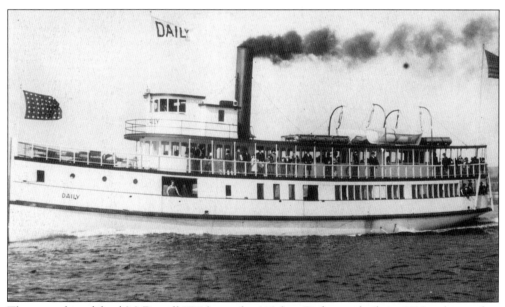

The seventh and final McDowell "D" boat, the 116-foot *Daily*, was built in 1912 at his yard at Caledonia to add to the East Pass route. In 1918, she was sold to the Canadian Pacific Railway for a Victoria–Gulf Islands–Nanaimo route as the *Island Princess*, though later renamed *Cy Peck*. In 1956, the *Motor Princess* replaced her. (MOPS.)

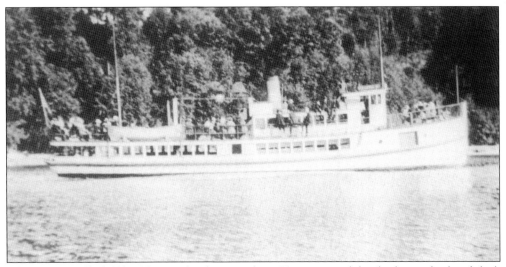

Christensen called all his *Virginias* by their numbers. *Two*, seen with her high guardrail and sleek lines, was built in 1912 on the beach at Lisabuela by Morris Shain, Christensen's second partner. She frequently raced with Merchants' Transportation Company's *Sentinel*, and twice they collided before the companies agreed that *Two* would carry passengers and *Sentinel* would transport freight. (Ronald and Constance Burke.)

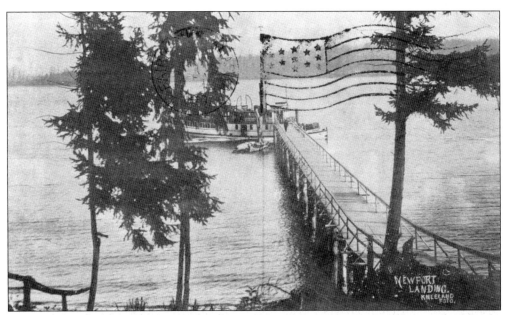

Newport Beach wharf, shown on this 1910 postcard with the *Vashon* moored, lies north of Burton on inner Quartermaster Harbor. Originally privately built, in 1915, it was replaced by King County using lumber from the old dock and the nearby Judd Creek trestle, though the piling, handrail, runway, and float were all new. As with most of the island docks, it was dismantled in the early 1930s. (VMIHA.)

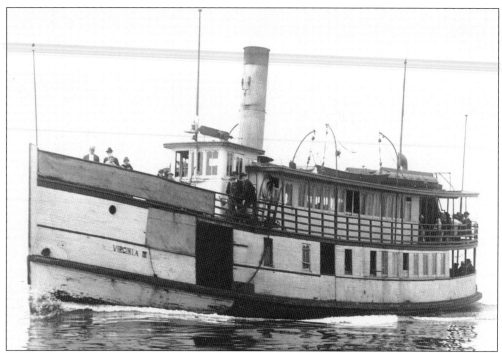

The *Virginia III* had four names, not one of which was *Bull Run.* One day on the West Pass, a bull was loaded onto the foredeck where he shattered his crate and chased a deckhand aft. At the turn, the deckhand scooted up the starboard side, but the bull lost his footing and dived off the stern. Now subdued, he was rescued and safely delivered. Originally built in 1910 by the Lorenz brothers as their second *Typhoon,* she was bought by Christensen and remodeled for the West Pass route in 1914. Repurchased, renamed *Narada,* and looking much the same (below), in 1927, Ed Lorenz put her on a Seattle–Port Ludlow run. In the mid-1930s, a new owner changed her name to *Salmon King.* She was laid up in Lake Union in 1944. (Below PSMHS 1671.)

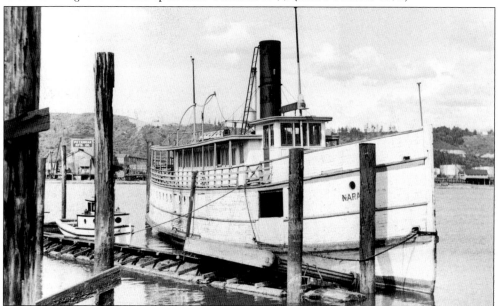

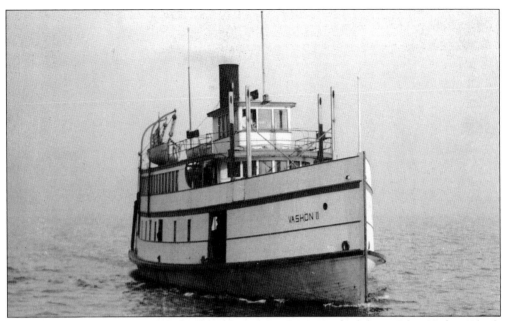

In 1917, Wiman and Manson, the Vashon Navigation Company, had the 106-foot *Vashon II* built at Burton by Taylor and Grandy. She replaced *Verona* on the Quartermaster Harbor–Tacoma route until 1922, when she was sold to Kitsap County Transportation and renamed *Manitou*. In 1937, she went to Puget Sound Navigation, and from 1943 to 1958, she served as a floating clubhouse for Seattle's Tyee Yacht Club.

When McDowell ceased business in 1918, leaving a gap in East Pass service, Christensen bought *Tyrus* from the Lorenzes, renamed her *Virginia IV* and put her on the West Pass opposite *Three* on the East Pass. In 1921, she was sold to Crosby Towboat. In 1922, Canoe Pass Packing bought and converted her to a diesel cannery tender. She sank near Juneau in 1935. (VMIHA.)

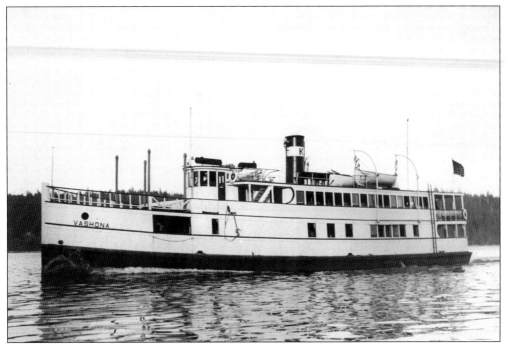

The 110-foot *Vashona*, built for Manson by Martinolich in 1921, ran 10 years on the Quartermaster route before car ferry service on Vashon's south end made inroads on her business and she was replaced by the smaller *Concordia*. *Vashona* then began a new life as an excursion boat, the *Sightseer*, touring Lake Washington and the Ship Canal until 1962. (MOPS.)

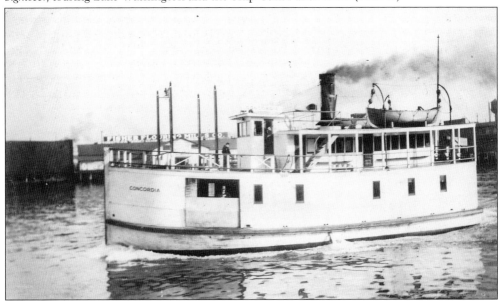

Originally the *Concordia* was 67 feet, but Vashon Navigation discovered a length under 65 feet required one less crew member and had nearly three feet lopped off, giving her that truncated look. *"Conkie"* was built in 1931 to replace *Vashona* and handle the dwindling custom on the Quartermaster route. Converted to diesel in 1937, she was sold in 1938 and laid up in Lake Union in 1976. (KPHS.)

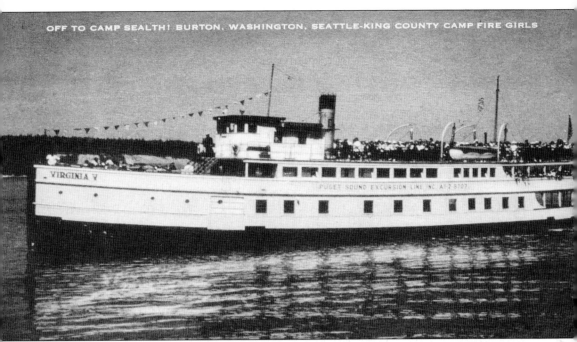

The *Virginia V* is the last operating wooden-hulled steamer of the Mosquito Fleet. Built by Matt Anderson at Maplewood, she was an amalgam of features owner Nels G. Christensen admired in earlier boats. The hull was designed after *Virginia III*, the superstructure after Manson's *Vashon II*, and the familiar "West Pass Whistle" also came from *Three*. The Heffernan triple-expansion steam reciprocating engine was installed from the 1904 *Tyrus* (renamed *Virginia IV*) and remarkably continues to power the boat to this day. Carl Lorenz's iron eagle, an emblem originally mounted on his Lakebay sawmill and subsequently on five of the Lorenz boats, now sits on the high-pressure cylinder cover of the *Virginia V*'s engine. *Five* was launched March 9, 1922, christened with water from Christensen's creek, and her new master was Christensen's son Nels C. During her 16 years on the West Pass route, she carried more than three million passengers, including thousands of Campfire children to Camp Sealth, while averaging 46,000 miles annually or nearly 750,000 miles by 1938.

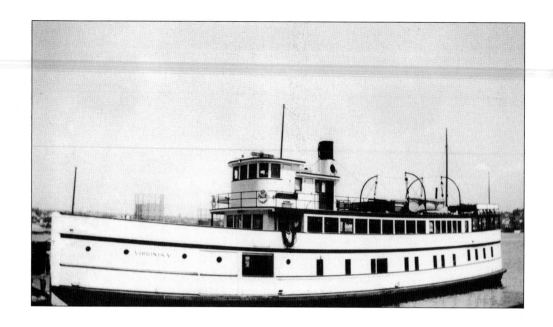

The *Virginia V*, as she was originally built, is pictured above. A later view is shown below. The *Virginia V* had only one accident when, in October 1934, hurricane-force winds beat her against the dock at Olalla, causing $11,000 damage and losing her whistle overboard. Later it was found by two small boys and reinstalled. *Five* was rebuilt and returned to the route within two months. In 1935, Nels G. died, and the next year, his son died. The business faltered, was sold for debt in 1942, and ownership has changed at least six times since. Now with National Historical Landmark status conferred in 1992, *Five* is owned by the *Virginia V* Foundation, which purchased her in 1980, had her restored, and continues to operate her on excursions.

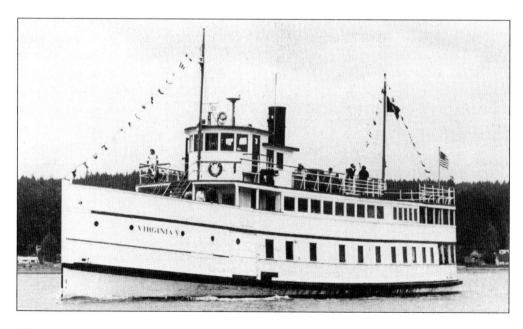

Five

OLYMPIA, TACOMA, SEATTLE

From this early-1900s photograph of its busy waterfront, it is clear why Tacoma was "The City of Destiny," as several steamboats are tied up along the Tacoma Municipal Dock. The *Tyrus* lies in front, with the *Vashon* next behind, followed by the *Daring*. Gangplanks, called "brows" by mariners, wait for the *Indianapolis* and the *Greyhound* on the dock. Though the Panic of 1893 was an economic setback, Tacoma had a population of 38,000, was the western terminus for Northern Pacific Railroad that built wharves and developed the waterfront, and was home to St. Paul and Tacoma Lumber Company (1888), which made Tacoma "the lumber capital of the world," and Foss Launch Company (1889), a name now synonymous with towboating on the whole West Coast.

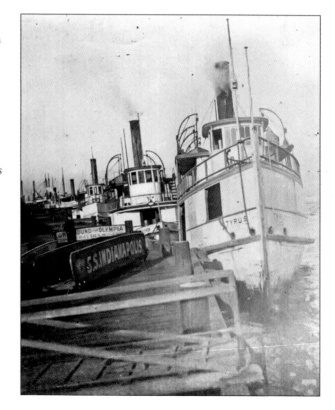

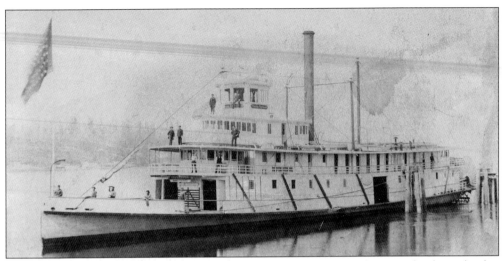

The luxurious 177-foot stern-wheeler *Emma Hayward*, built in Portland in 1871 for the Columbia River, arrived on Puget Sound in 1882 to make daily round-trips from Olympia to Seattle with a stop in Tacoma for Northern Pacific train connections to Portland and Spokane. In 1891, when faster rivals appeared, she returned to the Columbia, where she ironically finished as a shabby towboat, making her last voyage in 1900. (MOPS.)

The 262-foot iron side-wheeler *Olympian* was a speedy but expensive boat, for though she could run at 26 knots, she used 50 tons of coal between Tacoma and Victoria. Built in Delaware in 1883, she began her Northwest career in 1884 but was laid up in 1890 in Portland, and while attempting to return to the East Coast in 1906, she stranded in the Straits of Magellan.

As befits her name, the 112-foot *Fleetwood* was reputed to have raced nearly every steamer on the Sound and seldom lost, though once, in 1890, she and the much-longer *Olympian* vied all the way from Seattle to Tacoma with the *Olympian* beating her by only 50 yards. This caused a reporter to remark, "it looked like a test between a whale and a herring." Built in 1881 in Portland, the wooden propeller steamer came north in November 1886. Under her gingerbread cabin and peaked pilothouse was a serious boat whose speed could be counted on when needed. For example, in June 1889, she carried firemen and Olympia's new steam fire engine to help fight Seattle's Great Fire. Running up West Pass with a fair tide, she made the trip in a record three hours and 30 minutes. In 1905, she was abandoned on the beach at Dockton. (MOPS.)

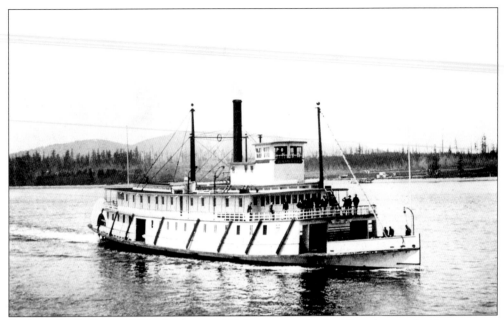

Built at the Dalles in 1880, the roomy, 160-foot stern-wheeler *Hassalo* was the first steamer constructed by the Oregon Railway and Navigation Company. She worked the middle Columbia until 1888, when she was piloted over the Cascades Rapids at low water and taken to Puget Sound to run Olympia-Seattle-Bellingham. In 1892, she returned to the Columbia and was converted to a towboat, but in 1898, she was destroyed.

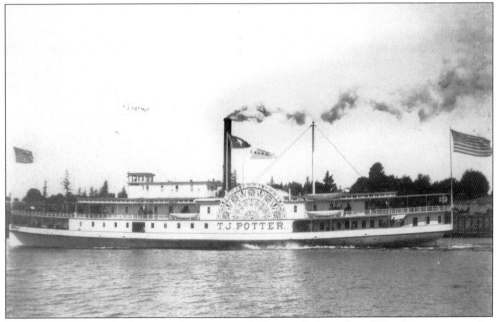

Sporting an ornate wheel cover and containing the largest firebox of any West Coast steamer, the 230-foot *T. J. Potter* was among the speediest boats on Puget Sound. Built in Portland in 1888, she operated on the Columbia River before spending two years on the Tacoma run. She returned to the Columbia, was extensively rebuilt in 1901, and continued to serve until 1920. (MOPS.)

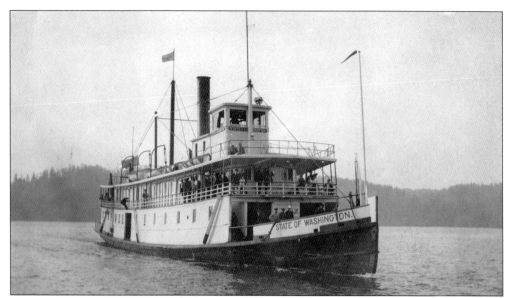

Tacoma-built in 1889, the *State of Washington* came down the ways already at work, her steam up and her wheel turning. In her life on the Sound, she had routes south, north, and into Hood Canal. In 1913, she went to the Columbia River, and about 1915, she became a towboat. She was demolished in a boiler explosion in 1921 that injured six crew members and killed one.

The 243-foot propeller *Victorian*, built in Portland in 1891, had one excursion on the Columbia and then went to Puget Sound where, with declining passenger patronage, she proved too expensive to operate and was laid up. She came out of retirement to replace the *City of Kingston*, which sank in 1899, and then was used for Alaska trade. Later she was converted to a car ferry.

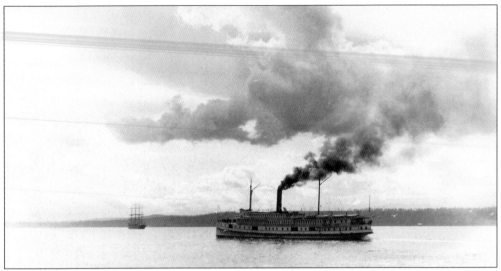

Built in 1884 in Wilmington, Delaware, for Hudson River trade, the 246-foot, steel-hulled propeller *City of Kingston* came to the Northwest in 1890. Equipped with stateroom accommodations for 300 and three decks, her route established Tacoma, not Olympia, as the southern terminus for the international run from Victoria. In 1899, *Kingston* was rammed in heavy fog off Brown's Point and sank, though her upper works separated and floated long enough for everyone's safe rescue. Many of her fittings were salvaged; the gilt eagle from her pilothouse now resides at the Museum of History and Industry, and her bell served for many years as a dinner gong in Foss Launch and Tug's Tacoma cookhouse. Below, in dry dock at Esquimault, British Columbia, the flared deck emphasizes her elegant steel-hull design. (Below MOPS.)

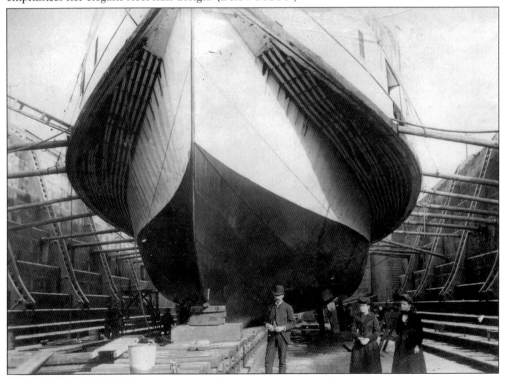

Call the *Greyhound* by any of her nicknames, "the wheel and the whistle," "wheelbarrow upside down," "flying clotheshorse," "the pup," or "the hound," she was still a speed queen. A plain boat, 139 feet long but only 18 feet wide, she was lean like her namesake and cruised at 13 knots. With her raucous whistle and 20-foot wheel (below) towering over the one low-slung deck topped by a single, exceptionally high stack, she came to the Sound in 1890 newly built from Portland. Her pilothouse was adorned with a gilt greyhound and a broom (to sweep the waters of competition), and though she raced often and victoriously, she at last lost these emblems to the *Bailey Gatzert*. In Tacoma in 1924, her hull was converted to a mooring float for Foss Launch and Tug Company. (Both MOPS.)

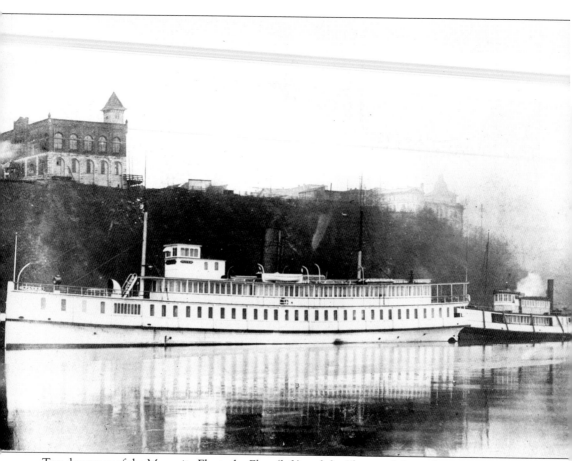

Two doyennes of the Mosquito Fleet, the *Flyer* (left) and the *Fleetwood*, lie tied up at Tacoma. The 170-foot *Flyer* was so slender when she was launched in Portland in 1890 that she rolled over and had to be sponsored out—a second hull wrapped around the first. It was imperfectly sealed, so tons of water sloshed between the hulls, yet she still broke speed records. Her 2,000-horsepower triple-expansion engine (though never operated at more than 1,200 horsepower) produced a cruising speed of 16 knots that took her on the 28-mile trip from Seattle to Tacoma in just under 90 minutes. One could "Fly on the *Flyer*" promptly, and once, despite running against a record gale, an insurance inspector checking the boat between Alki Point and Point Robinson found only a minute's difference in running time. After 28 years of four round-trips daily, the *Flyer* had steamed almost two million miles and safely carried three million passengers. In 1917, she was rebuilt as the *Washington*.

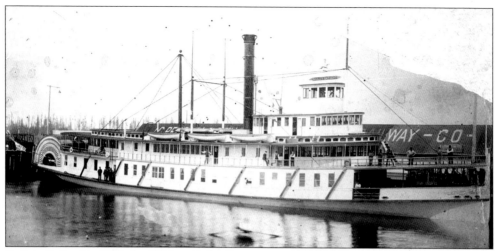

Built in Ballard in 1890, the 177-foot *Bailey Gatzert*, named for a former Seattle mayor, worked on the Seattle-Tacoma-Olympia run for two years before going to the Columbia River for excursions and the Portland-Astoria route. During the 1905 Lewis and Clark Exposition, she was so popular she inspired the song "Bailey Gatzert March." Her 22-foot wheel, below, and her 22-by-84-inch non-condensing engines made her speedy, but not enough to best the *Greyhound* (except once) or the *Potter*. In elegance, she had no peer; her interior decor and murals were planned and painted by a British artist named Harnett. In 1907, she received a heavier hull, another 17 feet in length, and engines from the steamer *Telephone*. A decade later, Puget Sound Navigation bought her for the Seattle-Bremerton run. (Above MOPS.)

Launched in Aberdeen, Washington, in 1897, the 116-foot *T. C. Reed* ran at Grays Harbor. In 1902, new owners put her on a Tacoma-Seattle route via West Pass until 1904 and then tried a route from Shelton to Everett by teaming her with *Nanette*, which covered the Shelton-Tacoma leg while the *T. C. Reed* steamed Tacoma-Everett. The *T. C. Reed* was beached in Oyster Bay and dismantled; *Nanette* was converted to a tug in 1907. (MOPS.)

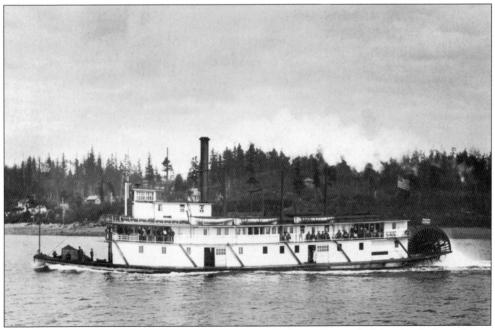

The 150-foot *Capital City*, built in 1898 at Port Blakely, was intended for the Stikine River. Instead, she never left Puget Sound and plied Seattle-Tacoma-Olympia until 1911. She had one mishap in 1902 when she and the Canadian freighter *Trader* collided, tearing a hole in her port side. Managing to beach herself before sinking, she was repaired and returned to her route. (PSMHS 438-2.)

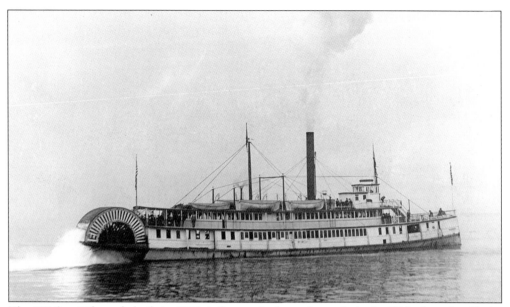

The 185-foot *Telegraph*, built in 1903, is famous for her role as victim in 1912 when the Alaska steamship liner *Alameda*, unable to stop in time, rammed her at her mooring alongside Colman Dock, sinking her and toppling the famous clock tower into Elliott Bay. Amazingly, there were no casualties; the *Telegraph* was raised, repaired, renamed the *Olympian*, and served another two years before being laid up.

In 1906, the *Indianapolis*, the first of the three (with *Chippewa* and *Iroquois*) steel-hulled, Ohio-built Great Lakes ladies to come west, began her 24 years on the Tacoma-Seattle run. Never as popular or glamorous as the *Flyer* or *Tacoma*, she ignored all challenges to race, preferring to meet her schedule in her own dependable way. One of the last steamers to retire in 1930, she was scrapped in 1938.

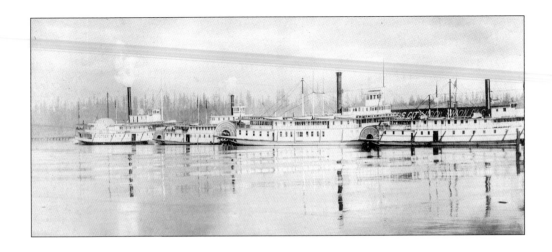

Washington statehood spurred the maritime transportation industry, so perhaps more famous steamers came to the Sound in 1889 and 1890 than in any other two years combined. Though the first new breed of propellers had appeared, the queens of the steamboat paddle wheelers are seen above, from left to right, moored at Olympia's City Dock about 1890: *T. J. Potter*, *Multnomah*, *Bailey Gatzert*, and an unidentified boat. Cars and paved highways had not been thought of yet, making water still the best way for trade and travel. By 1910, though the Mosquito Fleet era would last another two decades, there were now well-established routes with fewer stops, so in the view of Olympia below, looking east along Fourth Avenue, there is a remarkably empty complex of wharves, and there was also now the option of interurban travel over land. (Above WSHS.)

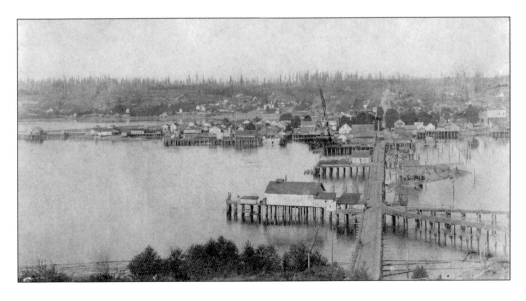

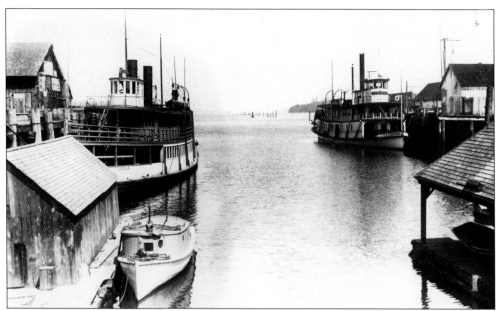

The propeller passenger steamer *Venus*, left, moored in 1911 at Horrs's dock in Olympia next to the *S. G. Simpson* at Percival's Dock, was a two-stacker built at Friday Harbor in 1907. She ran on various Sound routes including Seattle-Olympia until 1910, when Clarence D. Hillman bought her to use promoting his land developments. She was destroyed by fire in 1915. (Susan Parish.)

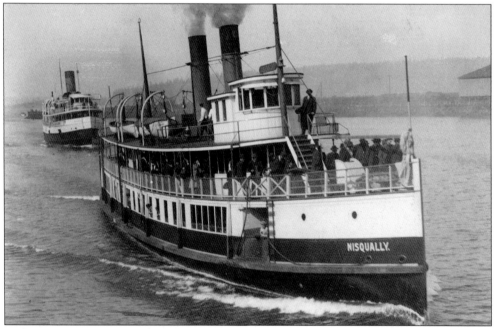

Built in 1911, the wooden 127-foot *Nisqually*, shown entering Tacoma's City Waterway with the *Indianapolis* astern, was one of the last steamers to ply from Olympia. In 1918, renamed *Astorian*, she ran Portland to Astoria, then came back to Puget Sound as a San Juan Islands freighter in 1923. That year, loaded with Christmas turkeys, she collided with a barge in Elliott Bay and sank.

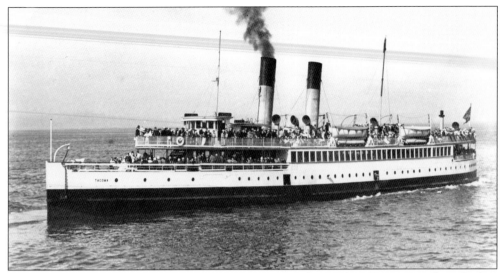

Christened by the governor's daughter, Florence Lister, the 221-foot *Tacoma* was launched in Seattle in 1913. Comfortable, with a spacious mahogany passenger cabin, and swift, with a four-cylinder triple-expansion engine and a top speed of 21.5 knots, she served on the Tacoma-Seattle run until 1930. Her last regularly scheduled service was a year on the Bremerton run before becoming an excursion boat.

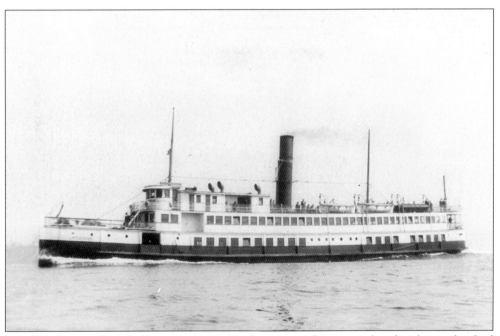

The *Flyer* became the *Washington* in 1917 when her upper cabin was replaced with one that had large view windows but no open deck. She ran on several different routes, but with the decline of passenger business, she was laid up then burned in 1929 for her metal while, according to the *Tacoma Ledger*, "hundreds of onlookers watched the flames eat [her] heart out."

Six

END OF AN ERA

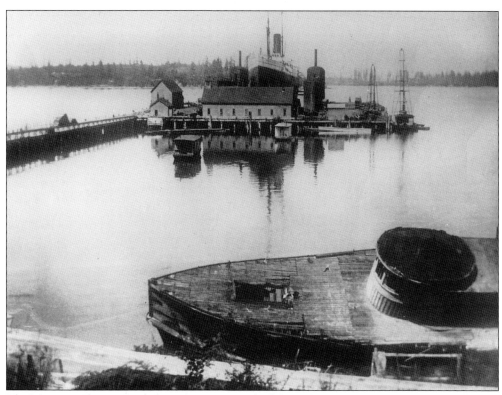

The Mosquito Fleet era ended as customers switched their allegiance to cars and paved highways. The traditional designs of the steamers were outmoded, too, as newer boats came down the ways with gasoline or diesel motors instead of steam, propellers instead of paddle wheels, and steel instead of wooden hulls. To survive, the fleet adapted, the larger boats finding new lives as ferries, the smaller ones as tugboats, freighters, or excursion boats. Some did not endure. They were scrapped or burned, or abandoned like the once-ornate *Fleetwood,* shown above on the beach at Dockton, stripped of her salvageable materials and left to rot in the elements while a sleek, coastal steamer watches from the dry dock. (MOPS.)

Although the little steamboat, the *Queen*, built 1902, operated on the Columbia River, this 1905 photograph illustrates that the Mosquito Fleet carried all kinds of cargo—occasionally even automobiles that had to be manhandled on and off like any other freight. The Hunts' *Atalanta* was known to carry cars in this way. (PSMHS 6358.)

The *Lydia Thompson* may have been the first to ferry a car across Puget Sound when, in the summer of 1906, the crew was asked to load a "machine" at Union City for an owner who couldn't drive on nonexistent roads to Seattle. The crew pushed the Stanley Steamer up a couple of planks, eased it over the rail, and settled it between the hatch and the mast.

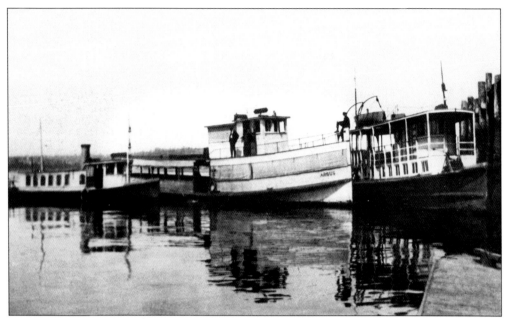

In the 1920s, many launches served feeder routes to Tacoma terminals for continuation on to Olympia or Seattle, such as (left) unidentified, *Argo*, and *Argus*, or others named *Lady Lou* or *Chickawana*, originating from Quartermaster Harbor, Caledonia, Redondo, Stone's Landing, or Dash or Brown's Points. By then, car ferries were taking over, and passenger-only patronage was declining. By the 1930s, they were gone.

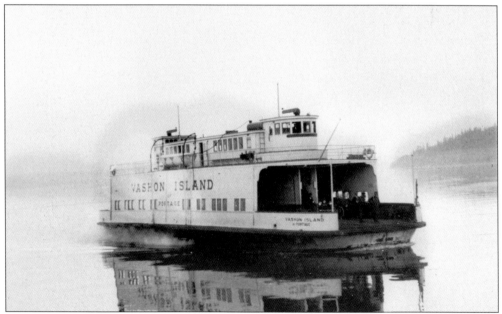

In 1916, the first new diesel-powered ferry was launched. Built for King County as an extension of the highway system, the *Vashon Island* made four round-trips daily between Portage and Des Moines. At 119 feet long, she could carry 300 passengers and 30 small cars. In the early 1920s, her route moved to Lake Washington, she was renamed *Mercer* in 1928, and she ran until 1940. (PSMHS 4382.)

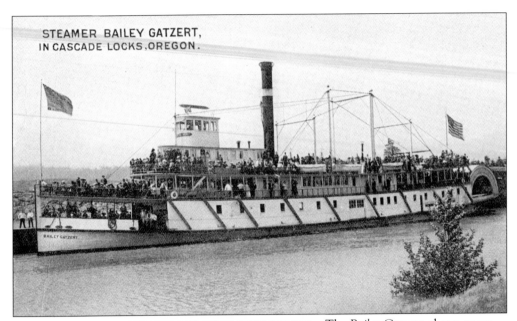

STEAMER BAILEY GATZERT,
IN CASCADE LOCKS, OREGON.

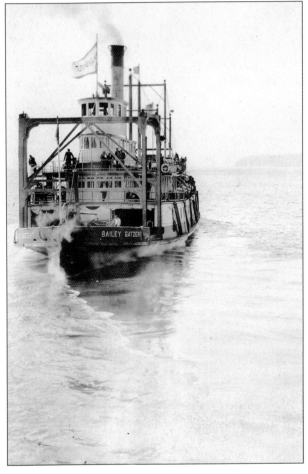

The *Bailey Gatzert*, above, as an excursion steamer to the Dalles on the Columbia River, was built in 1890. On Puget Sound, she ran two years between Tacoma and Seattle, then many years Portland-Astoria. In 1917, during wartime, she returned to Puget Sound for the navy yard route, Seattle-Bremerton. Soon after, she was sponsored out, and a Barlow elevator was added (left) to load and unload automobiles and freight. She remained on the Seattle-Bremerton run as the first car ferry service to the Olympic Peninsula under Capt. Harry Anderson, who later became operating manager of the Washington State Ferry System. She was laid up in 1926, and her hull was converted to a floating machine shop in Lake Union. (Left MOPS.)

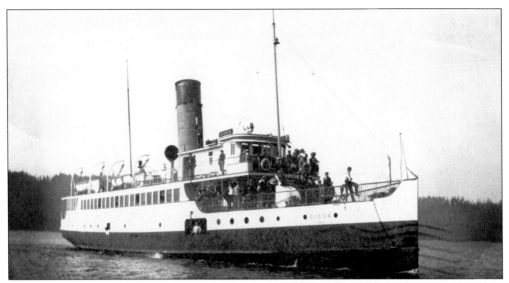

The steel-hulled, single-screw *Sioux* was launched in December 1910 and began service as a companion to the *Indianapolis* in February 1911 with the opening of the new Tacoma Municipal Dock. Between them, on the Seattle-Tacoma run, they left each port every two hours. After a year, she was placed permanently on the Seattle-Edmonds-Everett run. In 1924, she was rebuilt as the ferry *Olympic* and put on a direct run from Port Angeles to Victoria, where both Puget Sound Navigation and Canadian Pacific recognized tourism would help both companies. They advertised a number of driving-ferrying tours using their boats on a dizzying choice of routes and ports. After service in World War II, the *Olympic* went to Paramaribo, Dutch Guiana, and found a new life river running in South America. (Below PSMHS 1815-3.)

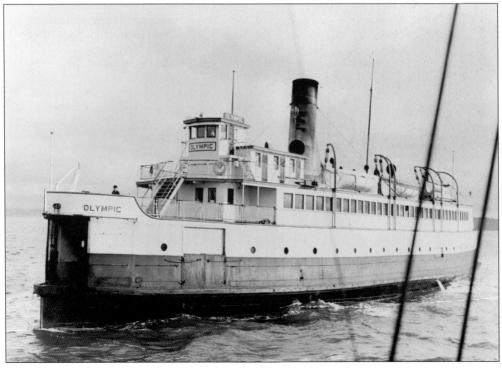

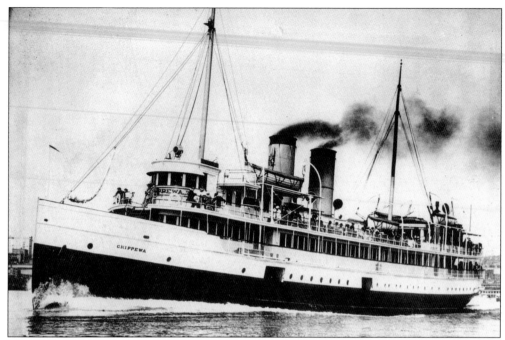

The *Chippewa*, pictured as she looked as a two-stack steamer for Puget Sound Navigation, came to the Northwest from the Great Lakes in 1907 and competed on a number of routes, including Tacoma-Seattle. A rebuild in 1915 replaced her wooden deckhouses with shiny steel. After lying idle between World War I and 1926, another rebuild converted her to a ferry capable of carrying 45 cars and 950 passengers. In 1932, more reconstruction produced the look seen below, where she could carry 90 cars, had a larger wheelhouse, a cabin that now accommodated 2,000 passengers, and one funnel for her new diesel engine. She continued running until 1965, after which her end was long and slow. Sold many times, she was eventually cut down to her hull and abandoned near Collinsville, California. (Both MOPS.)

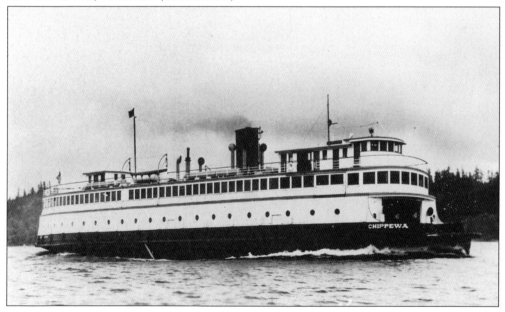

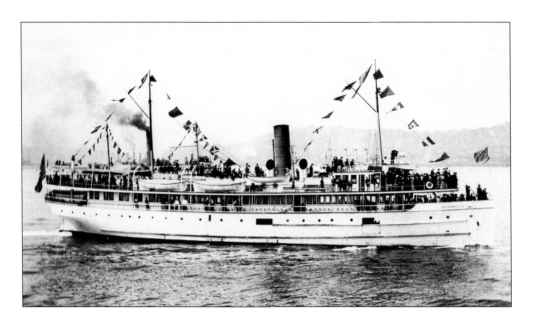

On May 23, 1908, two years after coming from the Great Lakes, a festive *Indianapolis*, above, brought sightseers from Tacoma to Seattle to join thousands of onlookers in welcoming 12 touring battleships from the Atlantic Fleet. Below, in 1933, with her hull painted the signature black of Puget Sound Navigation, the photograph shows her adaptation as a single-ended steam ferry that could carry 33 cars and 750 passengers. A turntable was installed at the aft end of the main deck to turn the cars to face the single access on her bobbed bow. This was not a particularly successful design, but she could still run at 16 knots, covering the Edmonds–Port Townsend route in 90 minutes. She was laid up in 1930 and scrapped in 1938. (Below MOPS.)

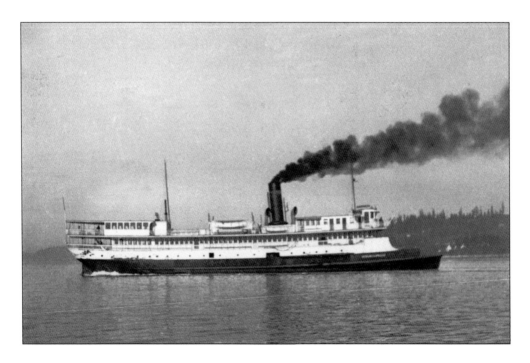

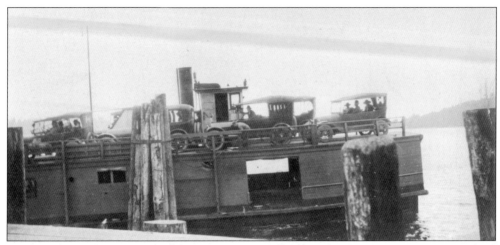

The *Transit*, powered by a wood-burning steam engine, was the first ferry to serve Fox Island starting about 1918. She carried six cars on her upper deck and passengers on the lower. Although she looked top-heavy and ungainly, she traveled safely between Fox Island, Wollochet Bay, and Tacoma. She caught fire in July 1925 while moored at the Titlow Beach dock and was a total loss. (FIHS.)

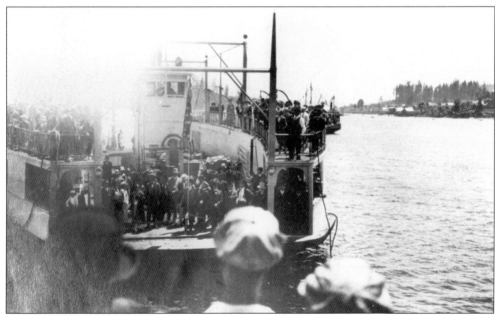

In 1917, Pierce County brought the 32-car, side-wheel steam ferry *City of Vancouver* from Portland. Rechristened *City of Tacoma*, she began a run between Point Defiance and Gig Harbor in 1918 when the road to the Point Defiance dock was completed. In 1920, eight years after Vashon Islanders began petitioning for car ferry service to Tacoma, Tahlequah was added to the route. (GHPHS.)

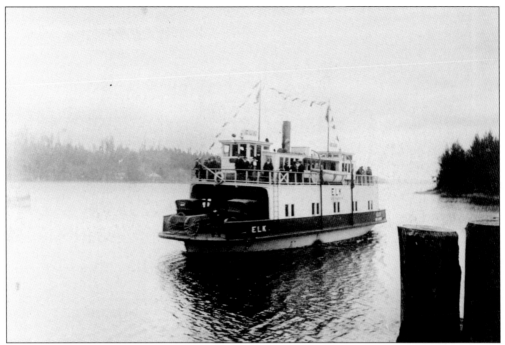

Pierce County awarded a ferry contract to Skansie Brothers of Gig Harbor in 1922 for a Steilacoom–Anderson Island–McNeil Island–Longbranch route that would use their new 67-foot, 16-car motor ferry *Elk*, shown above on her maiden voyage in May. By 1924, traffic had grown so much that Skansie built the 30-car ferry *City of Steilacoom*, which then served until 1937. (KPHS.)

In 1922, Mason County supplied ferry service to Harstine Island with a 40-foot scow, the *Island Belle*. She had a load apron on both ends, could carry three cars, and her 10-horsepower engine drove side-paddles for her three trips per day, three days a week until 1929. She was replaced by *Harstine I* (above) and in 1945 by *Harstine II*, which ran until a bridge opened in 1969. (MCHS.)

Built in 1903, the passenger steamer *Florence K.* (above) was owned by the Hunt brothers when they dissolved their navigation company in 1919. Arthur and Lloyd took cash, and Arda got the *Florence K.* In 1923, Arda had her converted into the 18-car steam ferry *Gloria* to run in competition with the ferry *City of Tacoma* between Gig Harbor and Tacoma. In 1925, Capt. Harry Crosby bought the *Gloria* and renamed her *Beeline* (below), a name in keeping with his other boats, *Airline* and *Crosline*. He used her as a relief boat on weekends for the *Airline*, which ran between Alki and Manchester. She then went to the Everett-Langley route until 1928, and in 1929, she joined the fleet of Puget Sound Navigation. (Below MOPS.)

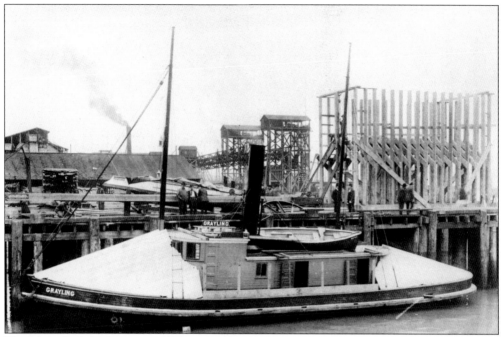

The *Meta*, built by Lorenz in 1888, was sold in 1898, converted to a cannery tug, and renamed *Grayling*. In 1906, she became a general towboat, and then was sold again for use in the Panama Canal construction. In early summer 1909, boarded up (above) and heavily loaded with coal for the 4,000-mile voyage, she was sighted off Cape Blanco, Oregon, and then was never seen again.

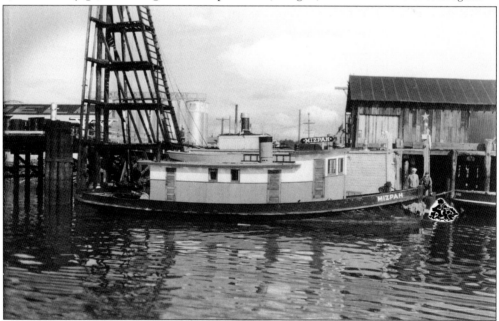

The *Mizpah*, familiar as a mail, freight, and passenger steamer in Carr Inlet after her 1905 launching, caught fire and burned to the water line in 1915. She was rebuilt as a steam tug with her pilothouse lowered to deck level, then converted to diesel, one of the first motor tugs in 1922. She sank in a 1934 gale but was recovered and continued work as a harbor tug.

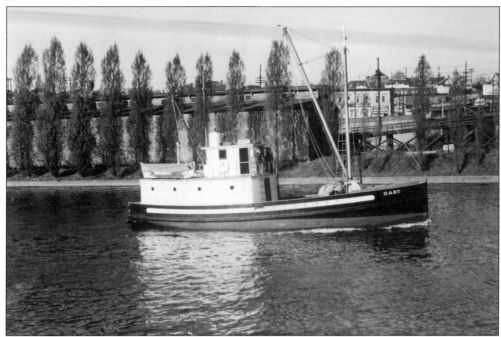

The *Dart* moved to Alaska for use as a mail boat after McDowell sold her in 1918. Returning to the Sound in 1925, she became a tug for Anderson Tug Boat. After she burned in 1928, her engine went to the ferry *City of Mukilteo*, she was rebuilt, her cabin and pilothouse were moved aft, and she returned north to work as a diesel freighter out of Juneau (above, in the Lake Washington Ship Canal).

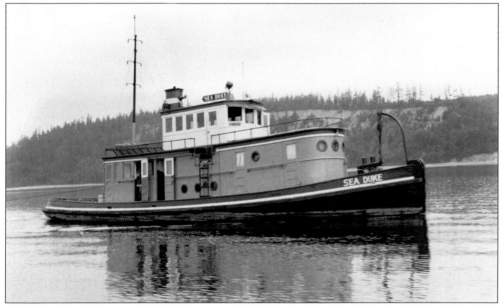

After the passenger steamer *Victor II* capsized off Point Defiance with two lives lost in 1916, she was raised and rebuilt as a tug for Delta V. Smyth in 1924, one of Smyth's eventual fleet of 32 tugs. From Smyth, she passed to Pacific Towboat Company of Everett and was renamed *Sea Duke*, above. She worked another 40 years before she was scrapped in 1964. (PSMHS 2284-3.)

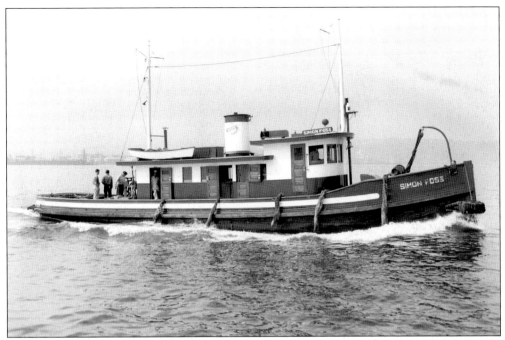

Built in 1897, the *Alice* became a tug in 1925 for Delta Smyth, who converted her to diesel power and replaced her cabins with a one-level deckhouse. In 1941, sold to Foss and renamed *Simon Foss* (above), she towed on the south Sound until 1963 and then spent 10 years as a beach house for marine historian Gordon Newell. Resurrected, she served as a tug once again. (PSMHS 797-3.)

When Foss bought Delta Smyth's fleet in 1961, it included *Audrey*, a former 1909 freight and passenger steamer turned shrimp trawler turned tugboat when acquired by Smyth and converted to diesel power in the 1940s. Small and low-powered, Smyth assigned her short-range tows. Foss placed her in the surplus category and sold her in 1963. (PSMHS 254-3.)

The *Vashona* was sold to Anderson Steamboat in 1931. In 1935, a rebuild enclosed her cabins, now refitted with easily opened windows for the comfort of her 300 passengers, and transferred the melodious chime whistle from the *Fortuna*. Rechristened *Sightseer*, she ran daily summertime excursions from Lake Washington through the ship canal to Elliott Bay until 1962.

Renamed the *Silver Swan*, the freighter *Ronda* was converted to a diesel-powered Lake Washington charter boat in 1947. When Puget Sound Navigation workers struck, tying up the ferry fleet in March 1947, *Silver Swan* ran commuter service from Vashon to downtown Seattle. A second strike in 1948 saw her on the Suquamish-Indianola-Seattle route.

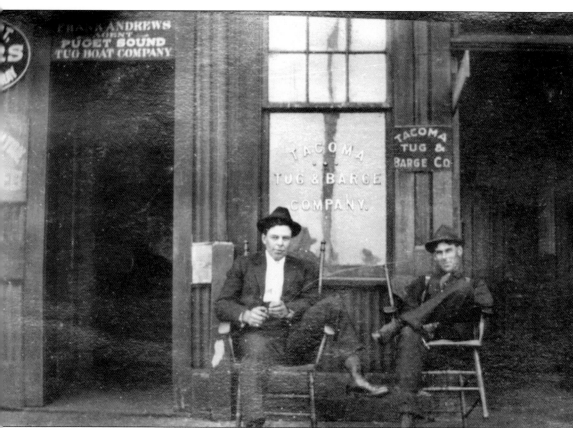

In this photograph, Thomas William "Billy" Phillips, left, relaxes in Tacoma with an unidentified friend. His demeanor does not suggest a résumé that reads like a who's who of Mosquito Fleet steamboats. Born in Olympia, October 1, 1877, Phillips began his maritime career at 14 for Capt. John Vanderhoef on the *Glide*. Later he worked on the *Skagit Chief, City of Kingston, Rosalie, City of Seattle, Sehome, Fairfield*, and *Magnolia*. His first command was on the *Dove*, followed by the *Vashon, Verona, Vashon II, Vashona*, and *Virginia V*. Like those steamers, he too adapted to a life after steam and served on ferryboats. His last post was master of the Puget Sound Navigation ferry *Kitsap*. While landing at Point Defiance one day, he slumped to the floor of the wheelhouse with a heart attack. He had already signaled the engineer to stop the engines, and the pilot-less boat eased into the slip as though his hand were still on the wheel. Taken to his home at Burton on Vashon Island, he died a few days later on August 6, 1949.

BIBLIOGRAPHY

Arledge, R. T. *Early Days of the Key Peninsula*. Vaughn, WA: Key Peninsula Historical Society, 1998.

Bashford, James. Miscellaneous Papers. Museum of Puget Sound Collection, 1932–1941.

Burke, Ronald and Constance. "The Lakebay Steamboats and the Families That Knew Them." *The Sea Chest* (March 2007): 101–116. (June 2007): 183–201.

Cammon, Betsey Johnson. *Island Memoir: A Personal History of Anderson and McNeil Islands*. Puyallup, WA: Valley Press, Inc., 1969.

Carey, Roland. "The Carolyn Has Undergone Many Changes." *Marine Digest* (January 22, 1983): 11–16.

———. *Isle of the Sea Breezers*. Seattle: Alderbrook Publishing Company, 1976.

———. *The Sound and the Mountain*. Seattle: Alderbrook Publishing Company, 1970.

———. *The Sound of Steamers*. Seattle: Alderbrook Publishing Company, 1965.

———. *The Steamboat Landing on Elliott Bay*. Seattle: Alderbrook Publishing Company, 1962.

———. "The Steamboat Name Game is Confusing." *Marine Digest* (September 18, 1982): 11–19.

———. *Van Olinda's History of Vashon-Maury Island*. Seattle: Alderbrook Publishing Company, 1985.

Cleveland, Elton Guy. *The Steam Donkeys Are Calling*. Self-published, 2005.

Davidson, Bertha M. (Gabrielson). *Parade of the Pioneers: A History of the Early Days of Vaughn, Washington*. Gig Harbor, WA: Peninsula Gateway, 1961.

Eckrom, J. A. *An Excellent Little Bay: A History of the Gig Harbor Peninsula*. Gig Harbor, WA: Gig Harbor Peninsula Historical Society, 2004.

Faber, Jim. *Steamer's Wake*. Seattle: Enetai Press, 1985.

Fredson, Michael. *Log Towns*. West Olympia, WA: Minuteman Press, 1993.

———. *Oakland to Shelton: The Sawdust Trail*. Belfair, WA: Mason County Historical Society, 1976.

———. *Shelton's Boom: The Classic Years (1910–1933)*. Shelton, WA: Northwest Arts Foundation, 1982.

Gordon, Robert B. Sr. *Magnolia Beach Memories*. Self-published, 1999.

Hitchcock, Beulah, and Helen Wingert. *The Island Remembers: A History of Harstine Island and Its People*. Shelton, WA: Harstine Women's Club, 1979.

Kline, M. S., and G. A. Bayless. *Ferryboats: A Legend on Puget Sound*. Seattle: Bayless Books, 1983.

MacDonald, Alexis. *Fox Island: Its History and Development*. Fox Island, WA: J&J, 1966.

McDonald, Lucile. *Early Gig Harbor Steamboats: Based on the Journals of Emmett E. Hunt*. Gig Harbor, WA: Mostly Books, 1984.

Miller, George L. *Fox Island: A History*. Fox Island, WA: Fox Island Historical Society, 1993.

Morgan, Murray. *Puget's Sound: A Narrative of Early Tacoma and the Southern Sound.* Seattle: University of Washington Press, 1979.

Neal, Carolyn, and Thomas Kilday Janus. *Puget Sound Ferries: From Canoe to Catamaran.* Sun Valley, CA: American Historical Press, 2001.

Newell, Gordon. *Pacific Tugboats.* Seattle: Superior Publishing Company, 1957.

———. *Ships of the Inland Sea: The Story of the Puget Sound Steamboats.* Portland: Binfords and Mort, 1951.

Newell, Gordon, ed. *The H. W. McCurdy Marine History of the Pacific Northwest.* Seattle: Superior Publishing Company, 1966.

Oles, Floyd Hall. *Glencove: Scenes from a Puget Sound Boyhood.* Self-published, 1986.

Perisho, Caroline. *Fox Island, Pioneer Life on Southern Puget Sound.* Fox Island, WA: Echo Bay Press, 1990.

Phillips, James W. *Washington State Place Names.* Seattle: University of Washington Press, 1971.

Ramsey, Guy Reed. *Postmarked Washington: Jefferson, Clallam, & Mason Counties.* Burtonsville, MD: The Depot, 1978.

———. *Postmarked Washington: Pierce County.* Tacoma, WA: Washington State Historical Society, 1981.

Sagerson, Mary, and Duane Robinson. *Grapeview, the Detroit of the West.* Shelton, WA: Mason County Historical Society, 1992.

Skalley, Michael. *Foss: Ninety Years of Towboating.* Burbank, CA: Superior Publishing Company, 1986.

Students of 1974–1975, Goodman Middle School, Gig Harbor, Washington. *Along the Waterfront: A History of the Gig Harbor and Key Peninsula Areas.* Tacoma, WA: Clinton-Hull Printing Company, 1979.

Thomas, Berwyn B., and Fredi Perry. *Shelton: The First Century Plus Ten.* Shelton, WA: Mason County Historical Society, 1996.

Thompson, Wilbur, and Allen Beach. *Steamer to Tacoma.* Bainbridge Island, WA: Driftwood Press, 1963.

Warren, Richard E. "Dockton: The Drydock Years." *The Sea Chest* (June 1969): 134–149.

Wight, Chauncey. *Echoes of Yesterday on Fox Island.* Self-published, 1966.

Wright, E. W., ed. *Lewis & Dryden's Marine History of the Pacific Northwest.* Seattle: Superior Publishing Company, 1967.

Across America, People are Discovering Something Wonderful. Their Heritage.

Arcadia Publishing is the leading local history publisher in the United States. With more than 4,000 titles in print and hundreds of new titles released every year, Arcadia has extensive specialized experience chronicling the history of communities and celebrating America's hidden stories, bringing to life the people, places, and events from the past. To discover the history of other communities across the nation, please visit:

www.arcadiapublishing.com

Customized search tools allow you to find regional history books about the town where you grew up, the cities where your friends and family live, the town where your parents met, or even that retirement spot you've been dreaming about.